The
GOD-BLESS
cart

J.W. Fleming

I'd like to give a huge thanks to Alan Watts, I am so grateful you came into my life when you did! As well as all the people I have met along the way, that influenced and made this book possible. Thank You!

GOD-BLESS!

AUGUST 8, 2020
WRITTEN AND ILLUSTRATED BY:
J.W.Fleming

1

Sssshh, ssshh, the sound of a red spray can was softly heard down the alley, back out behind a local retail shopping store. The wet, candy red paint now read, "PLEASE HELP!" as it dripped down both sides of the cardboard walls.

Two walls, nearly 7 feet high, by 7 feet wide were attached on both sides of the shopping cart. The shopping cart, now appearing to look much like a rolling billboard on wheels. The cardboard was fastened to the cart with small, twisted pieces of chicken-wire. Similar to that of giant, twist-ties of barbwire.

It was around 6 months ago when he had spray painted his first cardboard sign asking for help, and about 4 months, since spray painting his last. A year ago, Moose never thought in his life, he'd ever be pushing a shopping cart like this one. Moose was used to pushing shopping carts full of merchandise out of retail stores, but never in his life thought he'd be pushing a shopping cart that read, "PLEASE HELP" across each side.

He had pre-cut some letter stencil's, out of pieces of cardboard he pulled out of a big green dumpster. While inside the Wal-Mart buying red and white spray paint, someone had went and stole his stencils he had just cut out. He had been inside the store for no more than 10 minutes while someone had come and helped themselves to his things. That were left momentarily outside in the shopping cart. As it sat, pushed up against a green dumpster along the back wall of the building.

Now, each of the carboard walls on each side of the shopping cart in wet paint read, "PLEASE HELP! SPARE CHANGE? GOD BLESS!" Throwing the half empty spray cans into the shopping cart. Now all he had to do, was attach his porcelain

angel to the top of the cart. After that, the 5-inch wheels of the shopping cart would be spinning off to be parked at the end of a local drive-thru line. Making itself part of the scenery, out in the parking lot. Leaving nothing behind but a few stray zip-ties scattered on the ground.

2

It was now mid-July, it seemed like the seasons were running a couple month's behind this year. All the rainy weather making it feel, much more like the month of May. The days, more common to be filled with dark clouds then that of the hot summer's sunshine. It definitely wasn't feeling like the beginning of summer, as the raindrops didn't seem they were about to quit anytime soon.

Moose, was 37 years old. A previous life of sex, drugs, and crime had left him alone against the world. 18 years had now passed since he had entered the world

as an adult. Maybe, he just needed another 18 years to grow-up. Some might say, "Some just live a little faster" or "Maybe some just take a little longer to find their way!"

Over the years, Moose had blamed his dad for sending him off into the world, 20 steps behind in life. After Moose entered the world, as an adult on his own. All his friends and family were gone and he maintained minimal contact with his son and daughter. He felt alone and lost in the world and was starting to feel hopeless.

For just over 6 months now, the covid-19 pandemic had been ripping apart countries all around the world. It was also known as the coronavirus, a blood red round sphere with ears sticking out, all around. Ears similar to that of the kids cartoon, Tele-tubbies.

Facemasks and hand sanitizer were now the mandatory, as the sheep and wolves began to split in society. Any type of socialism was banned, and social distancing was enforced. Basically, wearing a hazmat suit in public was about to start looking like the new norm. Retail shortages of toilet paper, face masks and hand sanitizer buzzed the news and the media.

Justin Trudeau, the Prime Minister of Canada at the time had passed a Canadian Emergency Relief Benefit, also known as the CERB, before the house of commons. Any Canadian without work was entitled to a CERB payment of $2000 dollars a month, from the government. Making sure to take alee precautions with anyone, "Speaking Moistly!"

When Moose received his first CERB payments, he had just been accepted into Digital Marketing and Social Media Management class with a school out in

Calgary. The course was online, and he could do it on his laptop, over any Wi-Fi connection. Thinking he could use some of the student loan money towards getting a place to live, off the streets. It had been a cold winter of sleeping next to the ATM machines, while the bank was closed for the night.

The school had decided to hold his student loan money for 6 months, until he had finished half the course. The school knowing that he was homeless when going through the enrollment applications to be approved for the funding. He felt intentionally set up for failure right from the start and was given unfair treatment to other students. Who receive their funding to cover their expense's through the beginning, of their classes.

With the first two months of the CERB payments paid out at once, Moose set out in Edmonton with $4000 dollars in his pocket to find a place he could rent, get off the streets and begin his schooling. After looking at a few vacancies and calling around, he still couldn't find any accommodation's that would rent to him.

All Moose could find, was the same usual nonsense and silly games it seemed everyone enjoyed playing with him. After seeking around all the community supports to help with any kind of housing, he still couldn't find anyone willing to help with housing, shelter or any sort accommodating to begin class. Finding only the constant siren of an emergency vehicle, or harassment of bright headlights following in the distance. Always close by, watching while they crept in the shadows.

Everyone had been advised to self-isolate and take precautions throughout the pandemic crisis. Focusing the fight on the virus by stopping the spread. He couldn't understand why it was so hard for him to find any other type of support

to help him find shelter from the streets during such an emergency crisis. He had the money needed and was still sleeping on the sidewalk.

After a few day's of searching for housing in Edmonton and the start date of his first class beginning in less than a week, it came down to 2 choices. One being a motel, two and a half hours west of the city. Another, also a motel, two and a half hours east, opposite side of the city. Both motels were $900 dollars a month and he could cover that with his CERB payment.

Moose had no problem making the choice east. It was simple, his daughter lived there, and she was turning 11 years old in the next couple months. Without the CERB benefit he wouldn't have been able to begin his schooling. He started his studies by learning the qualities of becoming a master student. Followed with a course on Moodle's Cengage, Outlook, Word and then onto McGraw Hill where he began his first core subject, Marketing.

At the beginning of the new year, Moose had went on a big digital kick. Him and his daughter had scanned all of his old photo albums and downloaded them to a hard drive. He also scanned all his keepsakes and drawings from when he was a kid. During his studies at the motel, he also bought a few course's in photoshop and Corel. Beginning to convert his old oil rig photos he took, while working as a roughneck on the rigs over the years.

For the first two months at the hotel, he found himself stressing about being able to pay the $900 dollar rent at the motel each month. The CERB payments had only been approved for 4 months and with the uncertainties of the pandemic, he just felt there was a lot of uncertainties about anything these days.

His daughter didn't like visiting him at the motel and the pandemic wasn't getting any better. Which didn't help much with the thoughts of a second wave to begin at some point. A second wave was for sure to come. As history always repeats itself, as with any of the other previous pandemics always following with a great depression. He had already started stocking up on canned food's and rice not sure of what to expect with the new life happening in society. The new world was sure to be a new experience for everybody.

Figuring preparing for a second wave was the best gamble, he left the motel in the third month. He needed something more long term, without the monthly stresses at the motel. He was paying way too much for the dive, the motel was and needed a more positive environment for his school studies. A place that his daughter would enjoy coming to visit. Bottom line, he needed to think long-term survival, with all the future uncertainties in the world. Somewhere safe for the rest of the pandemic that was consuming everything and everyone around him. Somewhere Moose wasn't going to stress, about being back on the streets at the end of the month.

While searching online for older campers and R.V.'s. there wasn't anything much under $5000 dollars. Not coming without alot of work or leak repairs and a whole bunch, wrong with them. Looking on the Facebook marketplace, he found a 1984 Bluebird school bus for $1400 dollars. Moose thought if he could get the school bus for $1000 dollars and then he put a $1000 dollars into it, "BOOM!" he'd have a house!

Then all he would need to do is get it out to a seasonal lake lot, that was still somewhere close to his daughter. It would be something he could actually afford,

a safe retreat for when the second wave did hit, and he would have a place to call home and not have to worry about a landlord or place for his things. A home base!

Moose, happened to know the guy selling the school bus. His name was Brad and he had worked on Brad's service rig 12 years ago. Before switching rigs to go and work for Brad's best friend, Lornie on Royal well servicing's rig 1. Rig 1 was a single single, meaning it pulled 1 joint of steel tubing and 1 sucker rod out of the deep oil wells at a time. Moose had worked for Royal for 2 years in the past and didn't care a whole lot for them after doing his taxes 5 years later. He was audited and dinged $5000 dollars later, due to some accounting errors, during the time while working there.

Brad accepted the $1000 dollar offer and Moose left the motel, also taking a leave from school. Spending what he had left from his CERB cheque on buying the school bus. For the first month away from school, he lived in a tent behind the school bus, on the side of an old fake friend's mechanic shop. He was allowed to use the power from the shop while he gutted and stripped out the insides of the bus. Moose, figured the fake friend either felt sorry for all the fake made-up drama over the years, or for stealing a $400 dollar winter jacket of his, one of the last times he had seen him.

After using more than a dozen grinding blades, finally all the stainless-steel rivet's holding the inside tin panels of the bus had been ground off. Which allowed him to remove all the tin panel's from inside the bus, the insulation underneath full of mouse poop and the smell unbearable. He ripped apart and stripped the insides of the school bus down until it was nothing but a bare

skeleton. Everything rotten and no good was to be removed and replaced, there were no cutting corners. Moose was going to build it properly, solid and perfect. The floor was going to go in first, making sure the foundation was solid, right from the beginning.

After gutting out the insides of the bus and begged his mother for $100 dollars, Moose sat on the floor heater that was supposed to be attached to the left side from the driver's seat, the drivers seat had been also removed. Driving the school bus over to the truck wash, he pulled it into one of the large, over-size wash bays. He began power washing the school bus, from head to toe. Making sure to wash out all the left-over traces of mouse feces that had been rotting away, sealed between the layers of tin steel that kept the school bus together for years. The interior of the school bus now looking like the insides of a silver tin, turtle shell. Moose dangled two, "New Car" scented air freshener's from one of the open exposed aluminum steel rafters that hung every 36 Inches across the span of the bus.

$84 dollars and he was done giving the school bus the bath of its life. Moose turned the key in the ignition, the bus roaring to life. VRroooom, VRrooom, the Chevy 454 engine howled from the hood of the 84 Bluebird. Howling through the large open wash bays of the truck wash, Moose kept pushing down on the gas pedal trying to avoid the engine from stalling. He shifted the school bus into drive, pulling forward as steam from the bus bath began rising, just before stalling and suddenly stopping 5 feet ahead. A few more turns of the key and the bus wasn't roaring back up again. The old girl didn't like her first shower in over 20 years, let alone the biggest cleanse of the school buses life. After letting it sit for a few minutes, the bus started back up and Moose parked it back in front of his tent.

Now with $16 dollars left, He needed money to purchase wood and supplies to start the overhaul of the bus. He started by returning his Wacom one drawing tablet he had just bought it a week before, buying the school bus. They just came out with a drawing tablet with a budget friendly price tag for anyone to buy at $550 dollars. He really didn't want to return it but knew he wouldn't be creating much Art with it until the bus was finished. He loved it and had planned to do big things with it. It was a great tool to have for his new direction in digital Art, but the school bus was Moose's number one priority.

"Six hundred and eighty something dollars!" The lady working at the home depot cash register said to Moose, as he began starting to look for items to remove from the shopping cart. Taking the costs down to the $550 dollars he had just received back for the drawing tablet. It was the first of a few trips to the hardware store and finding himself removing items from the shopping cart. Buying only what he had enough for, at the time.

Moose, now had a solid floor layed down inside the bus. After grinding all the rust infected areas of the steel, he filled the holes and sealed the bare, steel floor. Starting with a coat of roof tar, followed with a layer of 3/8th plywood, a layer of pressed insulation foam board, a layer of plastic moisture barrier and followed again by another layer of 3/8th plywood. He would later on lay the finished floor down, after the bus was nearly completed and also when he could afford the wood to finish the floor. As Moose screwed in the first-floor screw to hold all the layer's together, the screw bottomed out against the steel floor and began to push the wood up from the steel. He switched the forward/reverse switch on the drill, lowering the plywood back down, flush with the floor and left the screw

sticking out about a half inch. Only tacking a few screws down in place and replacing them all with shorter screws, securing the floor down later.

His friend Tanner, he knew from back home in Manitoba, brought a few hand tools and a set of work lights for him to use, even re-wiring a grinder back to life at midnight for him. Without Tanners help, the school bus might never made the progress it did, and might have taken months longer to complete the big renovation, Moose was now committed to.

After getting the floor laid down in the bus, he had to move it from the side of the mechanic shop. Another confrontation with his fake friend blew out of hand one morning. Moose had thought the blow-up was going to happen at some point and actually thought it was going to happen alot sooner than it did. His fake friend accusing him about a missing drill that was missing. After Moose brought up the missing winter jacket, things blew up quick with the fake friend saying, "Get your bus out of here in 1 hour! or I'm calling the cop's!" Moose, finding it funny that he was being called a thief, from the guy that stole a winter jacket from him. Not to mention all the tools in his mechanic shop were stolen from thieves, that the fake friend enjoyed buying stolen property from.

Of course, on the day to move the bus it was pouring rain. As Moose started to pack his things up that were laying along the side of the mechanic shop, he got dressed in his Helly Hanson rain suit. Still stained black with oil from his days out working on the service rig. He started walking to the gas station, filling a jerry can with gas to move the bus. It was a good thing he had bought the jerry can a week earlier and another good thing he had received his CERB payment for the month that morning or who knows how the day would have ended up playing out.

Now with all his things inside the school bus, Moose turned the key and the bus roared to life again. Sitting on a wooden box, in place for a driver's seat, he planned to take the bus only 5 minutes down the road, parking it at a storage yard just north of town. Moose had rented a storage unit out there in the past over the years and figured it wouldn't be an issue parking it there, until he figured out the next plan of attack.

That was all to be short lived, as the school bus stalled out in the entrance of the shop. The front half of the bus sticking out, onto the street now. Moose having no luck getting it started back up again, walked over to his fake friend spying from the doorway of his shop and shouted, "Thanks for F@#&ing with my bus!"

The rain was still coming down hard, showing no signs of letting up anytime soon. Shortly after the school bus had came to a stop halfway, out on the road, an R.C.M.P cruiser happened to drive by slowly but didn't stop. Moose having no registration, no insurance, no license or a permit for the school bus, made the decision right then to call a tow-truck. He'd just have the school bus towed, saving the hassle and mess of problems that could arise quick.

15 minutes later a bright yellow, heavy-duty tow-truck was seen turning at the intersection, down the street. Starting to head towards him and the school bus. Not much long after the tow-truck was hooked up, heading off towards the storage lot. With his luck, the storage yard was full, having no vacancies until later in the month. After phoning a second storage lot, the school bus was headed to another storage yard. A few kilometers west from the first, storage yard.

After punching in his gate code, near the front entrance of the storage yard, they passed by a bunch of shipping containers on the left. At the end of the road of shipping containers, they found a small clearing in the back for RV parking. Not looking like alot was going on back there, with just a few old campers and boats parked. Almost giving you the feeling that they had been abandoned there with their ripped up tarps hanging off them, flapping in the wind.

After finding the space he had been assigned to park the bus in, the tow-truck dropped the school bus into its new home, for the time being. The heavy weight of the tow-truck digging and leaving deep ruts in the soft sand that had been collecting moisture from the rain, early that morning. As well as the steady rain that was continuing to fall.

$32 dollars for parking in the storage yard was cheap for the month, the $250 dollar tow bill for the 10 min drive was rather high and a extra expense he really didn't need at the time.

3

It had been months since he sat next to a shopping cart beside a drive thru line. With his cardboard signs, attached to each side of the cart. He

had been sitting there for nearly, 45 minutes now. A few people had pulled up, handing him over a green twenty, a few blue fives and some small, handfuls of change. Clearing out their cup holders filled with loose coins, to make room for their hot coffee they just ordered. The day was going well, only the petty theft of his stencils, the only negative ripple in the day. The rain still holding off it's release from the cloudy skies, that loomed up above.

When Moose arrived at the drive-thru, he placed a cardboard box in the middle of the 2 walls. Up near the top of the shopping cart. Attaching the box to each side of the sign. Then placed his porcelain angel on top of the box, which allowed the angel to sit, perched up above the shopping cart. Last thing left for him to do, was place a few tea-light candles next to the angel and light them. She would always keep the light shining, as she sat up above.

Moose named the porcelain angel, "GOD-BLESS". He found the small porcelain angel, late one cold winter night. Finding her inside a donation bin, while out in Sherwood park. During his first few week's, when he had become homeless. While adapting to have a shopping cart, become his new mobile home on wheels. One he'd again, be pushing and pulling around the city street's and sidewalk's. Long after the freezing cold Canadian winter months were over.

"GOD-BLESS" was completely white, her hair brushed back, secured in place with a porcelain halo made of light, pink flowers. The flowers of her halo matched the 2 flowers she wore, on top of each one of her shoulders. Her dress also showed stitching and light outlines of pretty pink flowers. She was positioned on her knee's, kneeling forward, her hands together, held out in front of her. She may have portrayed an image, of a girl that was asking for help. Holding her

empty hands out, but maybe she wasn't asking for help and she was holding her hand's out, in an offering of peace?

Surprisingly, the little porcelain angel still had her hands and all her fingers. When the angel and Moose had first united, she had been holding a blue bird in her hands. Suffering a few tragic near misses while sitting up on her cardboard perch, above one of the past shopping carts. When a few of the earlier carts had flipped over on to their sides.

The first cart flipping over, crashing her to the ground, resulting with her releasing the blue bird as if it had flown off and out into the world, on its own. Moose never did find any traces of the blue bird on the pavement where the crash had occurred. Now the angel just had her hands held out empty, in front of her.

The porcelain angel played a musical tune from a wind-up mechanism, housed inside the bottom of her ceramic body. The guts of the musical box were now packed away inside a box somewhere back at the school bus. The angel soon found herself trapped, in a house made of wax and glass. Her glass house held out by a curled steel hook that was made for hanging flowers. The angel, trapped inside her glasshouse by many layers of wax, left behind from the many candles that burned through the nights.

The main role she played was, "Keeper of the Light!" While she was a part of the shopping cart, she'd always have a light illuminating beside her. Whether it be from a wax candle, an LED candle or perhaps the pink glowsticks she'd end up wearing one night.

It was now getting to be just after dinner time in the evening, as Moose reached into his pocket for a quick glance at his cellphone, time reading, 6:43 P.M. The rain was still holding off for now, but Moose knew the sky was waiting until the late hours of the evening, to release its rain down onto the ground. Making it for a cold, wet, dark night. Hopefully, he'd find a nice dry patch of concrete to battle through the night's misery while he slept. This night being, his first night away from the school bus, since taking on the big project. It was also his first night back sleeping on the streets, since making his way out east to begin his schooling. Moose, was already starting to miss being at the school bus already.

Sitting out beside the shopping cart, was a bright red, Ol'Milluakee toolbox on wheels. Making a comfy seat, after throwing a pillow on it. It also made a great backrest against the 2 lengths of aluminum that extended off the back. Making up the handle of the toolbox. The toolbox was quite large and spacious, able to hold all of his artwork and keep his electronics dry and from harm. Trusting whatever be placed inside the toolbox, would stay safe. Among his Bible and electronics, there was a silver aluminum frame inside, holding file folders that contained his artwork. The toolbox enabling him to have a peace of mind, knowing he never had to worry or endure the constant stress always protecting his personal, expensive items he owned without it. All the suitcase's he previously owned, were quickly destroyed while being dragged around the city's frozen winter landscape, inside the concrete jungle.

While sitting on a transit bus heading into the downtown core of Edmonton, he began his search for better options to protect his belongings. Spring was now beginning to show with its arrival of rain and wetness. Soon to be a much greater

battle to make it through, then the cold winter month's he had just overcome. All with no casualties to what he had left for belongings.

Thinking the safest bet for his things, was finding a large toolbox of some sort, on wheels to pull his stuff around in. He figured his cheapest option would be to start calling around to different pawn shops and see what they might have. After making a few calls, he found the Ol'Milluakee toolbox, at a pawnshop on Stony plain road.

For month's, the toolbox became his best friend. Not separating much at all from it. Only to leave it behind at the entrance of a retail store, while he went inside briefly. They traveled all over the city together, even making their way to Saskatoon once. Through ditches holding water or what snow was remaining from winter, they put on many kilometers together over many journey's, big and small.

A few drops of rain started splashing off his arm now. Moose had started to think about packing up and finding somewhere dry to sleep for his first night back out, sleeping on the streets. The day pretty much coming up to an end, as the only businesses open in the shopping centre were the Wal-Mart and a Pizza 73, just across the parking lot near the exit of the shopping centre. It was a good day, counting just over $200 dollars not including the change he had received over the evening.

"Do you want a coffee?" He heard a man shouting out to him, from an unrolled window at the drive thru. "Triple, Triple!" Moose, shouted back towards the car. The driver, a police officer who had just pulled up next to the drive-thru window sitting in an unmarked ghost car. After paying for his order, the officer pulled up

and handed Moose his coffee through the passenger side window. Just before saying, "Have a Good night!" Pulling out and away from the parking lot.

As the dark of night, continued spitting the occasional drop of rain on his arm, Moose started making his way over to the front doors of the grocery store, to his right. The green overhang of the entrance would keep the rain off, him and the shopping cart through the night. Just off the side of the front doors, he layed down his sleeping bag on top the cold concrete, crawled in and closed his eyes.

Sleeping through the night, as the sky now finally decided to release its rain in a downpour. The large overhang to the entrance of the store keeping him and his two companions, dry. When he did open his eyes the next morning, he'd see an older lady sitting at a picnic table. Wearing her green and white uniform while enjoying her morning cigarette before work started. Just before her early morning shift in the deli or bakery perhaps. Still feeling rather tired and not really wanting to open his eyes to greet the day, Moose immediately fell back to sleep.

As soon as hies eyes opened the second time, the alarm in his head went off, telling him it was time to move. The store was opening up right away and he didn't want any of the other morning worker's, or the manager seeing him . Sleeping, not far off from their front doors. As soon as he got to his feet, an older man was standing close by, pretending to look busy said, "You got to get out of here, now!" Moose not bothering to give him a reply back, was now throwing his sleeping bag into the shopping cart. Noticing the miserable old mans silver Chevy half ton, out front parked next to the curb.

Then cleaned up any garbage that may have been left on the ground, where he had claimed for the night. The coffee the officer gave him at the end of the

night was still sitting on top of his toolbox. After throwing the coffee cup away, he grabbed the shopping cart and the toolbox and began the short walk across the parking lot. Again, to be parked next to the, "Thank You" sign at the end of the drive thru.

 The morning started off great after that, a regular guy maybe in his thirty's stopped in-front of the shopping cart, unrolling his passenger window. Handing Moose out a morning coffee, along with a $5 dollar bill folded up next to the coffee. The cream and sugar inside a small bag on the side. Moose handing him a piece of his Art in return, explaining what year the picture was taken, what rig he had been working on and what the image was relating to. They both exchanged smiles, each saying, "Thank you!" As the man drove off to begin his day.

 Minutes later, a lady stopped waving some sort of breakfast wrap in her hand. She motioned for Moose to walk over to the window of her car. Moose walking over with a piece of his Art he just picked out for her and then exchanged offering's. She also handed him a $10 dollar bill folded up next to the breakfast wrap. The lady staring briefly at the Art she was now holding in her hands, before smiling and driving off to start doing whatever her role was, that day.

 There was a short, early morning rush of exchanges of money and Art between Moose and the vehicles that stopped. As well, the people that had walked up to him and the shopping cart. Following the exchanges of money and Art, there were always exchanges of smiles, thanks and usually some positive words of inspiration for the day. Moose was doing good for the morning, it wasn't even noon and he had ate breakfast 3 times.

The sky was appearing to look to be alright for the day. Only a few, small white patches of cloud appeared in the bright blue sky, as the morning went on. It must have been around 1 o'clock in the afternoon now, as the rush of people out grabbing lunch had appeared to slow down.

The same silver, Chevy half ton with a property management logo on the side of the door now pulled up, beside him at the drive thru. The same miserable old man from earlier that morning, sitting behind the steering wheel. "You have to leave!" he barked out the window of his truck at Moose. "I don't want to hear it! I'm staying! do whatever you want or whatever you got to do!" Moose barked back at the old man who was now threatening Moose, "I'm calling the cops!" Moose snapping back at him again, "Go ahead!" while waving his arms in a motion towards the miserable old man to move on. "It's all made up, anyway!" Shouted out Moose, as the truck drove away.

Moose knew he had some really old warrants out in Saskatchewan, he wasn't too worried about it though. The Saskatchewan/Alberta border lay across the middle of town. He was on the Alberta side, thinking he should be fine. The cops never did come for him that day. He thought if they wanted him, they knew where he was, and they would have already came for him.

After the confrontation, he didn't stick around much longer. Figuring that he could use a change of scenery from the spot he had been parked at since mid-afternoon, the day before. Moose's plan now was to head east through town and head towards the shopping plaza that greets you when you first enter the city, from the east.

Maybe, making a quick stop at the Husky truck stop along the way, redeeming some of his husky rewards points in exchange for a quick shower. Washing off the night, sleeping on the street and whatever might have been crawling around, he may have not seen or felt while busy dreaming away.

Moose made his way across the long stretch of parking lot, making it another couple blocks further down the road and then decided to park the shopping cart at the end of a McDonalds drive-thru. There was an Original Joe's tap house neighbouring the drive-thru line. The doors of the Original Joes had been closed since they relocated near the center of town, just down from the town mall. Figuring he wanted to be at his destination across town before 8 P.M.

As the afternoon progressed the sky started becoming quite dark, quite quick. Only after feeling a few drops of rain hit his arm, had he noticed the black skies brewing, off in the distance, heading closer his way. The few random clouds overhead giving warning, to what was to come.

A couple of people had stopped with their change in hand while he was parked outside the McDonalds. Not much really happening through the course of the slow afternoon. The anticipation of having a clean shower getting the best of him, wheeling the cart the last couple blocks down the road to the truck stop.

Pulling up to the back side of the truck stop, he wanted to park the shopping cart just off the side entrance into the store. Making sure no one had the privacy to mess around with the shopping cart while he was inside having a shower. After a quick swipe of his rewards card, the cash attendant had his co-worker open one of the shower doors. Placing a towel inside the room, along the long hallway at the back of the store.

Moose, wheeling his big toolbox around the obstacle course of potato chips and chocolate bars inside the store, makes it to the hallway of shower doors and wheels it into the doorway that was just opened for him. Quickly getting undressed and standing under the hot water, closing his eyes and blanking out all thoughts in his mind, as the water ran down his back.

After he finished and walked back outside, he noticed the pavement was wet and the shopping cart had also been having a shower while he was inside having his. The rain, lasting only a few minutes seeing how it had already stopped. The real dark skies, continuing to display their presence off in the distance. He then began the second half of his trek, zig-zagging across town trying to take the quieter streets that ran alongside the busy highway.

Moose now crossed over the border from the Alberta side and was now on the Saskatchewan side. Getting not too far away from where he was headed, decided to make a final zig-zag through a residential neighbourhood situated just before the final stretch to his destination.

As he walked down the sidewalk, each side of the street was lined with rows of houses. A Pilipino guy about his age shouted out to him from across the street. He had been sitting in the grass outside of his house gardening and was now standing, waving him over. There was also a Pilipino working on a car with its hood up in the air, sitting in the driveway. Another Pilipino sat on a milk crate in the driveway, next to the car. His face, no further than 5 Inches from the screen of his cellphone. Moose parked the shopping cart on the sidewalk and pulled his toolbox across the street, going over to see the three men.

The man doing the gardening who waved him over, was curious to learn what the shopping cart was about and what Moose was doing? After a short story about the school bus renovation he was doing, Moose flipped the lid of his toolbox and started showing him some of his Art he had with him. The man then asking Moose if he could get a picture with him? After taking a few pictures together, the guy ran off, up the front steps and into the house. Quickly returning from the house with a white envelope, containing the bright shade of green sticking out from the middle of the envelope. The guy pulled a couple green bills out, folded them in half and handed them over to Moose. After thanking him, Moose told the guy to pick out a few pictures, the guy wasn't really interested in the Art and didn't want any. It seemed he was only really interested in having his picture taken with Moose. Moose insisted that he take a couple pictures, finally getting him to agree on a couple pictures that didn't have an oil rig in them. As the guy took the 2 pieces of Art inside his house, Moose was now feeling like a movie star as he walked back over across the street.

As he grabbed the shopping cart with his other hand, the homeowner pulled into the driveway of the house Moose was just starting to walk away from. Wondering what the man was probably thinking when he got home finding the strange shopping cart parked on the sidewalk, out front of his house. He was now on the final stretch as the dark skies continued to still creep slowly behind him, following off in the distance.

As he pulled into the parking lot of the Tim Horton's and Co-op gas bar, there was an oil change business situated in the middle. A paper hanging on the inside of the glass on the front door saying, "Closed due to staff shortages due to the pandemic!" Moose decided to just park the shopping cart infront of the closed

business not having to worry about anyone coming to tell him to leave or give him any problems. Closed businesses were starting to be a common sight as the doors of businesses began closing more and more, during the wake of the coronavirus.

After completing his trek across town and getting the cart parked, Moose headed inside the Tim Horton's to order a chai tea and use the remaining balance on the gift card he had received earlier. A couple extra boxes of tea were always nice to have out at the bus.

An older couple, not much older than Moose were sitting at a table to his right, sporting leather motorcycle gear. While standing at the till ordering his tea, the lady from the table approached Moose saying, "I just seen you pull into the parking lot and wanted to pay for whatever you were ordering!" Then told the guy working the cash register, "I'm paying for his order!" Moose, telling her, "She didn't have to and that he was going to use a gift card he was given earlier. Also that he planning on ordering a couple boxes of tea as well." The lady dressed in leather still insisted she pay, so Moose placed his gift card back into his pocket.

Moose walked back outside and back over to the shopping cart, placing his tea down and retrieved a couple pieces of his Art from his toolbox. Then headed back inside the coffeeshop to give the Art to the lady, for her kind generosity while insisting that she pay for his order. After chatting briefly with her and her husband about the Art he had just gave them and a little about his school bus. The lady really liked the Art and had pulled out a $20 dollar bill out of her wallet from her purse. Insisting again for Moose to take it as she held it out to him. A few more thank you's after the compliments and he was headed back outside again. Over to the cart where his tea now also was waiting for him. As he sipped on the chai

tea, he stared off into the clouds that seemed to still be brewing the coldness hanging in the damp, air.

While continuing to sip on his tea, the couple dressed in leather were now donning helmets on top their heads and had pulled up and stopped on a silver BMW touring bike. The lady stepping off the back of the bike, placing some change in the silver pail hanging off the side of the cart and then handed Moose a highway bible for motorcyclists.

It was your ordinary small bible, the same size most kids get when they start school. This one containing short stories of motorcycle adventures that motorcyclists had experienced while out on the open highway with their bikes. Another thank you and some more positive thoughts to one another and Moose wished them a safe travel on their way back home to Edmonton. The motorcycle pulled away, off towards their destination.

After they drove off, Moose headed back into the Tim Hortons spending what remained on the gift card he still had in his pocket. Buying 4 more boxes of chai tea.

Not much else happened after that, as the gasbar had now begun to close and the day had now turned to night. The storm, still hanging off in the distance displaying it's occasional flash of lightning.

As Moose was relighting the candles beside the porcelain angel who was still perched ontop of the shopping cart, a native guy about his age pulled up in a shiny new Dodge charger. So shiny and new, it looked like he just drove it off the lot. It turned out the native fellow had just taken possession of the sweet sports car only a few days earlier. He unrolled his passenger window asking Moose,

"Sooo, what's your story?" Just before reaching over and handing Moose a $50 dollar bill, he was holding in his hand. After Moose set some Art on the passenger seat of the car, they also exchanged thank you's, following with compliments. The native guy complimenting Moose on his Art and Moose complimenting the native guy about his shiny new whip he had just bought. Then drove away with a rumble, heading in the direction he was headed. Moose thought it was time that he better pack up and get going in the direction that he needed to go.

The storm had slowly starting to sneak in closer his way, as the bright flashes were starting to glow brighter and more often. Moose's direction being, across the street over to the ball diamonds. Providing shelter from inside the dugouts, they had for the ball players and teams. To get to the baseball field, Moose needed to go back down the road a couple blocks, pass one of the town's hotels that looked completely vacant and hang a right after the gas station. Entering through the ball fields main entrance, to the stretch of road that connected all the ball diamonds.

As Moose walked up to the gas station, he suddenly has a craving to grab a Pepsi to enjoy when he arrived at the ball field. Parking the shopping cart next to one of the vacant gas pumps, he headed into the small store. As Moose is walking over to the drink coolers he shouts, "Fill her up!" Towards the gas attendant behind the clear plexi-glass prison, built around the cash register. The man behind the till scanning the Pepsi with a huge smile, trying to contain the giggles that were slipping out of his mouth.

Moose, continued down the road out behind the gas station, finally arriving at the ballpark entrance. Just a short, walk up the gravel road to the ball diamonds

remained. The feeling of comfort now settling in, knowing that he wasn't going to be dragging around his two friends anymore that day. Now, only having to focus on trying to make the sleepover at the ball diamonds, as enjoyable as possible. Until the morning allowed the sun to rise and shine, again.

After pushing the shopping cart into it's resting spot for the night, under the far end of the shelter the dugout provided, Moose sat himself on top the ledge of the wide-open window of the dugout. Looking out over the bases of the ball diamond, taking in the new surrounding's for the night. The Tim Hortons and Co-op now on the other side of the fence, across the highway.

After lighting up one of his cigarettes, Moose tilted his head back noticing a huge black spider hanging directly over his head. Immediately jumping off the ledge, he was sitting on. Stirred up, by almost banging heads with the humongous spider. he began walking laps around the ball field bases. Dropping down and doing sets of push ups, pushing off first base in-between his laps. After getting his blood pumping, Moose removed his shirt and began jogging laps around the field.

Not sure if it was the Pepsi, or the energy that the storm was creating in the air, that gave him the sudden rush of adrenaline. It could also have been the Martin Garrix playlist he was listening to, in his headphones. Sleep was nowhere on Moose's mind that moment, the work-out blocking any coldness hanging in the air, of the night.

While enjoying all the satisfactions his body was feeling after his exercise, he pulled out his blue and yellow sleeping bag from the shopping cart. The sky still hadn't shown any signs of rain falling from above, as he decided to just throw his sleeping bag ontop of the white picnic table, that was sitting just outside the door

leading into the dugout. Waking up through the night only for a few seconds, after feeling the odd splash of a raindrop on his nose, or cheek. The only parts of his body left out, exposed to all the elements.

When the sun came out and morning had begun, Moose woke up still laying on top of the picnic table. The storm passing by, dropping no more than a few raindrops on him through the night. While demonstrating its display of power, off in the distance. After waking up and getting up, off the picnic table he didn't stick around the ball diamond long. Beginning to pull out the shopping cart from inside the dugout, as soon as his feet touched the ground. Heading back down the gravel road leading to the entrance of the ballpark, turning at the gas station and back over the short distance to where he had been, the night before.

Was a slow start of things, that morning. Just the usual shiny, jacked-up trucks wearing dark, black tint not allowing you to see who's sitting behind them, driving. The aggressively, loud exhaust tips dangling off the rear of the trucks. Pulling in and out of the drive thru lines, awaiting their first sips of their morning coffee.

Even after the cold sleep ontop of the picnic table, Moose felt quite happy. He knew there was a good chance he was going to be back at his bus, sometime that day. Of course, after spending the cash he had just received over the past few days towards it.

Moose, knowing how his friend Mike ran his schedule between his work and leisure time, thought it best to give Mike a call early. Moose called Mike, but there was no answer.

Moose had known Mike for almost 18 years now, since he first got to town in search of the oil rigs. He spent his first day on a service rig with Mike, when his lazy, big cousin was too busy having a beauty sleep rather than go to work. His cousin sleeping through the phone call's and wake ups from the crew truck as it sat outside, waiting for him to get up and go to work. His big cousin being a no show and letting down his crew, allowed for Moose to take his place in the back seat of the crew truck, off to his first day of work on the famous oil rigs of Alberta.

Moose had dreamed of that day since his teens, growing up in Manitoba. Mike was his only friend over the years that stayed completely sober and maintained the family man, life. He probably should have listened to Mikes advice over the years, during which they maintained contact on and off. Maybe if he had listened to some of Mike's advice over the years, maybe Moose might not have been in the position he was in.

Mike, called back shortly after not answering, "Where are you at?" He said, "I'm in between the gas bar and Tim Horton's on the east side! Where are you at?" Moose, shouting back into his phone. Mike was on his way back from his coil tubing shop, which was just 5 minutes west on the opposite side of town.

"Well, can you maybe pick somewhere a little less busy?" Mike said into the phone. Sounding almost embarrassed to pick him up, and what Moose might possibly have with him. In a spot so open, with the possibility of so many eyes looking upon them. The thoughts of Moose possibly wanting to load a shopping cart into the back of his pickup truck had probably started to flash in Mikes mind. Even with the thought's, Mike was still on his way to pick him up with whatever

was in store for him. Mike, being no more than 15 minutes away, had Moose hustling to tear down the cardboard walls hanging off each side of the cart.

Starting first with removing the porcelain angel, then snipping the chicken wire ties that bound each side of the cardboard, to the shopping cart. After everything was removed that was attached to the sides of the shopping cart, he pushed the now naked shopping cart over towards the garbage bins. Pushing it in-between the bins and then headed back over to his things. Getting everything from inside the shopping cart into somewhat of a neat pile, so it didn't look like a complete mess when Mike pulled up.

As Moose was walking back to his things, A man, resembling a greasy uncle of his from Regina, walked up asking, "How are you?" "I'm great!" Moose replied. Why wouldn't Moose be feeling great? Mike was on his way, headed to the hardware store and then be back inside the Zen of his school bus. Already feeling the negativity about to come out of the mans words, "Well you know the Art business is a tough business!" Said the strange man. Moose ignoring what he had just heard, began to show him a few pieces of his work, just before handing the man one of his Art pieces.

Moose still in the process of getting all his things organized for Mikes arrival at any minute, now heard the strange man say, "I am an artist myself, it's a tough one!" The man still not showing Moose any of his work as an artist, the greasy man continued to go on speaking of a depressing story that Moose wasn't bothering to listen.

Mike then pulled up in front of them, saving Moose his ears from the depressing noise that the man so full of such negativity, was speaking.

Immediately loading his stuff into the back of Mike's truck. "You can have the Art!" Moose told the man, just before hopping in the passenger seat next to Mike and pulling away.

A few weeks earlier, Mike had told Moose that he had an old generator he'd sell him for $50 dollars. The first stop they made was Mike's house as they backed up the truck to Mike's garage and loaded the old Champion generator into the back of the truck. Only charging him $30 dollars in the end for the generator.

Moose had only been able to talk to his daughter on her birthday, which had been a couple days ago. He thought he'd call her and have her come out to the bus, later on that day. She had asked her dad for $100 bucks for her birthday. Moose ran into the bank across from the hardware store, exchanging $100 dollars for 100 loonies. His daughter was getting the $100 bucks she wanted, in loonies.

While inside the bank, he found his daughter's mom up with one of the bank tellers. When she was done, she talked to Mike while waiting outside for Moose to come back out of the bank. After a quick chat with his daughter's mom, she said that she would bring their daughter out to the school bus, later that afternoon.

Moose, now at the cash register inside the hardware store, was once again removing items from the shopping cart and spending every dollar he had left in his pocket. After spending the $450 dollars he had on wood and a few hand tools, he was now off towards the storage yard where the school bus had been sitting, the first few night's Moose had been away.

A sense of relief and happiness flowing through Moose's body when he first saw the bus again. As they unloaded the full truck that Moose had somehow

managed to fill up in an hour's time, he asked Mike to start up the generator before he left. Mike sliding the choke lever over while pulling on the pull-start, started up the generator. A couple puffs of black smoke shooting out of the exhaust pipe just before turning the lever, killing the fuel line. Then headed off on his way, leaving Moose out at the bus.

Not much had been getting done with the school bus since the tow over to the storage yard. It had only been a few days since the tow. He started to tidy up and organize the area inside around his desk. Getting his laptop and printer set up while making room at the back of the bus, for the lumber and supplies he had just purchased. It was a great sound to hear the generator purring near the rear of the bus, having power on demand made a huge difference. Moose could now head-off into the wilderness, off the grid or into the unknown. Having all sorts of power after he fired the generator up.

Shortly after Mike left, Moose was walking down to open the main gate to the storage yard and punching in his access code. Allowing his daughter, her mom, her mom's new boyfriend and her brother, Jacob, into the storage yard. Inside the bus, Moose had the loonies in a small black felt bag, sitting on a small floral plate with gold trim for his daughter. After thanking her dad, she gave him a big hug. Jacob, one of her brother's came walking up onto the bus, immediately shouting, "This is AWESOME!" They didn't visit for long after checking out the progress he had made. Mya, leaving with the $100 loonies from her dad along with a few pieces of Art for her and Jacob.

Moose continued working on cleaning up the inside of his bus, getting everything organized and somewhat in order. It was now getting late and he

would have to either stay at the bus for the night, or leave right away. After 9 p.m. the gates would lock and he'd be stuck out there until morning. Unless he called security to come and let him out of the gates, which cost $50 dollars to open. After a few nights of sleeping out in the rain, Moose figured what's one sleep over out at the bus?

4

Sleeping in past noon, from being up late playing around with Art on his laptop, Moose woke to someone knocking on the front swinging doors of the school bus. The generator still running out back behind the bus all night, must have caught the curiosity of someone wanting to see if anyone was inside the school bus.

Moose exited out the front doors of the bus to be greeted by a man named, Martin. Martin asking, "Are you living inside the school bus?" Martin had the storage space next to Moose, which had a couple snowmobiles on a trailer with a huge 20-foot dump trailer parked in front of the skidoo trailer. The dump trailer was full of garbage bags, full of empty bottles and cans. Martin told Moose he did not want them and could have them, if Moose wanted them and was short on money. Martin, also going to the lengths of telling Moose that if he could find a truck to help him, Moose could use the dump trailer. Only expressing real concern about the return of his orange tarp, which was tied down over the garbage bags when he returned the dump trailer.

 Moose phoned Mike again to see if he could help him with the bottles and cans that he was just offered. Mike busy now for a few day's, figured he'd might as well head back into town with another toolbox full of Art. He already had the cardboard signs made that he kept from the previous shopping cart, from the day before. That had now blown underneath Martin's sled trailer.

After running some Art prints through his printer and getting his things straightened out as best he could, he locked up the school bus. Strapping the tarp back down that was stretched across the roof and was off on his way, pulling his

bright red toolbox containing his Art. The cardboard signs folded up in a box, strapped to the top of the toolbox, with his duffel bag strapped on top as well.

 Moose, walked down the stretch of road past the shipping containers and was now at the front gate, beginning to enter in his gate code. The gate wasn't opening and after a few more attempts of entering his gate code and having no luck, pulled out his cellphone. A sticker above the keypad to enter your access code had a couple phone numbers to call, in case of an emergency. One being the number for the security that would let you out of the gate if you were locked in. The owner of the storage yard answered the other end of the line, asking Moose right away, "Hey are you living out there in the bus?" Moose began telling him how it had gotten late out there the night before and after a few nights of sleeping in the rain out on the streets of town, he didn't think it would be a big deal if he was to stay out there for a night. The owner of the storage yard hung up the phone.

 Moose called the number back a few times with no answer from the owner. He started placing his things over the chain-link fence that had 3 rows of razor wire strung out along the top of it. Throwing everything over the fence just before placing his red toolbox ontop of the fence and then lowering it down from there. Moose, slipped out between the small opening in the front gate, where it slid in and closed the fence surrounding the storage yard.

 After walking a short distance down the range road that led back into town, the owner of the storage yard called back. With some more words exchanged between the 2 of them, the call ended with, "You have until Friday to move your

school bus out of my storage yard, the gate will be opened for you then to do so and if you ever jump over my fence again, I will call the cops!"

Now, the sudden stress began building inside about moving the bus so soon again, finding another place to park it and another tow bill. Trying to forget about the call he just had, he kept on his walk into town. Down the truck route that led in towards the towns shopping centre.

While walking down the truck route towards the busy Yellowhead highway that ran through the middle of town, he noticed 2 men wearing high visibility construction vests looking out over the stripped roadway in front of them. Accessing their big day ahead of repaving the street. As Moose walked by pulling his toolbox behind him, he yelled over at the 2 men, "Hey, you guys interested in buying any Art?" The man wearing the red supervisor vest replied with a smile, "Why, what do you got?" Then began walking over from where they were standing across the street.

Moose started removing everything he had strapped down on top of the toolbox, lifting the lid, placing his Art in each of the 2 guys hand's. The man handed him $20 dollars and then asked him, "May I have 2 more pieces for another $20 dollars?" The supervisor, really seeming to be interested in the Art. Then asked Moose if he would be willing to come and take pictures of the road crew, as they resurfaced the street in the morning. Then make some Art with the pictures for the guys.

After exchanging phone number's, Moose continued his walk, off towards the shopping center on the west end of town. The stress that he had just been filled with, forgotten with thoughts of his first gig in the morning. Taking pictures and creating Art for the road crew.

After arriving at the shopping centre, Moose grabbed a shopping cart from the parking lot and began pushing it over towards the drive-thru line. He already had the cardboard signs made, so it was quick tying them on with chicken wire. After, he parked himself back at the end of the drive-thru line where he was, just a few days earlier and lit the candles next to the porcelain angel. Sitting at her spot, on top of the cart.

Just after he had finished assembling the cart, people began pulling up, waving money in their hands from the front seat of their vehicles or walking up placing money in the silver pails that hung out on the cart. The trade offs between change and Art began. Following with the thank you's, smiles and compliments for the next few hours. Moose, still excited with his first chance at having the opportunity to create some Art after taking pictures of the men at work, the next day.

A girl pulled up with her young daughter sitting in the backseat, "Brooke!" Moose shouted at her. "What the hell are you doing?" Brooke replying. He began telling her about his school bus and his Art he was creating from his old pictures, over the years. The last time they had seen each other was out in Edmonton, a couple years back. She told him that she wanted some of his Art and was going to head over to the bank and she'd be right back.

He resumed back to sitting on top of the red toolbox while she was gone. After about 20 minutes, Brooke pulled back up handing him $40 dollars. As he handed

her some Art to pick from, she began telling him what's new and happening in her life at the moment. Then drove off to take her daughter home, who was getting tired and wanting out of her car seat.

The last few hours left in the evening, turned out to be quite enjoyable. A little bit of the stress of having to move the school bus again, had started to disappear. The day had been full of bright sunny skies into the evening, as evening now began turning into the darkness, of the night. As the night extinguished the light of the day, it couldn't put out the light shining next to Moose's, porcelain angel. The thoughts of not having to deal with any rain overnight, was also a great feeling to the start of his next struggle.

As midnight approached, Moose began thinking of where to find shelter for the night. Thinking he wouldn't be needing the overhang of the front doors to stay dry, he pushed the shopping cart over next to the Subway. Next to the Subway was one of the only places in the shopping centre that had 2 park benches on the sidewalk, connecting all the shops and businesses.

Thinking it be best to get himself up and off the cement while he slept, he thought the steel park benches would be perfect for keeping him up off the ground for the night. The lid of the toolbox was left cracked open with his tablet playing music inside, through the night. While the porcelain angel shined on top of the shopping cart next to her candles. Moose stretched out his sleeping bag on the bench and began to fall asleep.

Moose woke up early in the morning, as the sun began to rise. He would see a man walking away from him after placing a breakfast sandwich on top of the red toolbox. Moose, quickly asked the man to hold-on for a minute so he could give

him some Art before he got back into his vehicle. "We're good!" The man shouted back, as he closed his driver door to his vehicle and drove off beginning his day. Moose looked at his cellphone, the time reading 5:48 A.M in the morning.

Moose figured he would try and avoid any morning confrontation and get up to start the day as-well, after eating the breakfast that was just left out for him. Pushing the shopping cart back over to his spot at the end of the drive thru he had basically claimed over the recent days. As he pushed off, he noticed the candles finally blow out after burning through the night.

After getting the shopping cart parked back up next to the drive-thru, a few hours went by and he thought of when he should start making his way over to where he had met the 2 construction workers the night before. Moose wearing his oilfield coveralls had already made about $200 dollars not counting the change since leaving the school bus the day before. Decides to push the cart across the street over to a quieter spot, taking a break from the early morning. Waiting for the Bell store to open before heading over to where the road crew was to be working.

He wanted to go into Bell, to inquire about getting a MI-FI device hooked up to his existing cellphone plan. This would allow him to be able to do his schooling anywhere over this new device that he was just recently been told about. It would enable him to have a WI-FI connection anywhere on his laptop that picked up a cell signal. Which was pretty much anywhere. After finding out the new device would cost over $800 dollars to have hooked up and $800 dollars he did not have, that option was tossed out.

After leaving Bell, Moose walked back over to the shopping cart that was left along one of the rock islands out in the parking lot. As he was about to start making his way to the road construction crew which were only a few blocks away, a white police cruiser pulled up in front of him, the cherry's flashing on top of the car.

An officer got out asking Moose, "What he was up to?" and then asked him for a piece of his photo I.D. Moose handed him his photo I.D. and then began to explain how he tried to deal with his Saskatchewan warrants a few months earlier when he first got to town and wasn't able to. The officer reassuring him that he wasn't going to arrest him if the warrants were from Saskatchewan.

The officer hopped back into his car and began running Moose's I.D on the laptop that was peeking over the dash from inside the police cruiser. After fooling around on his laptop for abit, the officer got out of his cruiser and started putting on his leather gloves that were tucked into his back pocket. Then placed hand cuffs on Moose's wrist's, which were now behind his back, placing him under arrest and into the backseat of the police cruiser.

The officer began to collect Moose's belongings from the shopping cart. He made sure to advise the officer to be careful with removing his porcelain angel, as the officer began ripping his things from off and inside the cart. Leaving nothing behind but the cardboard wall's, that now half-hung on each side of the shopping cart. Again, asking the officer to be gentler with his things, who showed no consideration for any of his belongings as he jammed the red toolbox and threw everything into the back of the cruiser. After moving some body armour out of the way, the officer slammed down the hatch of the trunk and pulled away from

the shopping cart, heading towards the town's detachment near the center of town. The officer, making a call to dispatch to have by-law come take care of the shopping cart and the cardboard that was left, hanging on it.

After arriving at the detachment, Moose had his cuffs removed and was told to sit down on the wooden bench, while the officer brought in his things that he had jammed into the back of his cruiser. As Moose was being lodged into one of the prison cells that were inside the police station, he overheard the phone call to the officer from by-law saying they had dropped the shopping cart out back behind the detachment. The officer shaking his head and looking quite annoyed after receiving the phone call. Moose began to smile, as he was placed inside the cell and was waiting to see a Justice of the Peace about the court matters that had occurred years prior.

Not getting the best sleep on the park bench the night before, it wasn't long before Moose was curled up and sleeping under the grey wool blanket in the cell. Moose only waking up when the food hatch slammed down as it opened and created a temporary shelf for his meal that was now sitting on it. A microwavable hamburger and a small styro-foam cup of coffee premixed with the cream and sugar, now sat on top of the food hatch. After eating he fell back asleep, waking up the next time he heard the food hatch slam open again.

This time, a muffin and a coffee were placed on the hatch. A muffin meant that it was now morning. A few hours later, he was seated in a room containing only a phone and spoke with the Justice of the Peace about his release.

The outcome of the hearing was, they were releasing Moose sometime later, that same day. Moose was led back down to his cell and curled back up under the

grey wool blanket. The food hatch dropping again. This time, half of a microwavable pizza sub was placed on the hatch next to the usual mixed coffee. After grabbing the food and drink off the hatch, the guard that placed the items on the hatch, slammed it shut. The steel hatch echoing off the steel door that it hung from, which kept him locked away from the rest of the world.

It seemed like it had been hours had since he had been given the pizza sub. After hearing the commotion of the cell's being opened and shut down the hall for awhile. Moose figured court had to have been finished for awhile now and the detachment must have received his court papers by now as well. Moose layed down on the floor in front of the cell door and began stomping on the steel door with the bottom of his foot repeatedly. The loud bangs echoing through the cellblock and had to have been heard through the upper office levels of the police station.

It must have been a good 10 minutes of kicking the cell door before it opened with an officer standing over him in the doorway of the cell yelling, "WHAT ARE YOU DOING?" Moose still laying on the floor in front of the cell door, shouted back at the officer, "I'M DONE WITH THE GAMES! YOU MUST HAVE MY PAPERWORK BY NOW!" "WE HAVE YOUR PAPERWORK!" the officer was last to say, before leading Moose down the hall to his belongings. Which were now up on the counter ready to go for his release, where he had first entered the detachment before being lodged into the cell. After signing his name on the new paperwork that was just put together for him, with the new court dates to attend, the officers told him that the warrant from Yorkton was still out there and if he was to go onto the Saskatchewan side of the border, that he may be arrested

again. The Saskatchewan border being just half a block away on the other side of city hall, which neighboured the police station.

Moose was now kicked out the backdoors of the detachment and stood there with his red toolbox and his belongings in a pile for a quick moment, figuring out his game plan. He held in his hand a clear plastic bag which held his wallet, identification, the money he had on him, as well as his belt and the rest of his personal effects. Even the shoelaces from his shoes had been removed and were now vacuum sealed along with his contents, inside the clear plastic bag. Moose gathered his thing's back ontop of his red toolbox and began walking away from the detachment.

As Moose was walking by the tall fence that surrounded the dumpsters out behind the detachment, he suddenly smiles as he remembers the phone call the day before from by-law about the shopping cart ending up at the detachment. Moose, thinking now that he might be able to find his cardboard signs in or around the detachment's dumpsters, starts walking over to investigate.

He looked through the gaps in the fence boards and could see the cardboard to his sign, and if you wouldn't believe it, found the entire shopping cart parked between the two dumpsters. Behind the fence surrounding them. The cardboard still half-attached to the cart. Moose opened the doors to the fence, pulling out the shopping cart from between the two dumpsters. Quickly throwing all his things into the cart before running it over the grass hill and off the police department property, parking it on the sidewalk. Moose then ran back over by the dumpster, grabbing his bright red toolbox and rolled it over to where the

shopping cart now sat. Doing all this, while the tongues of his shoes were hanging out from where the laces, once used to be.

With his toolbox in one hand and the shopping cart in his other hand, he made a break for it, from out front of the detachment to the middle of the shopping centre across the street. When he got there, he began starting to fix the damage to the cardboard where it was hanging off the sides of the shopping cart. Placing his porcelain angel back ontop of the cart and lighting her candle. The detachment still staring at him, from across the street where he was standing, in the middle of the shopping centre.

Moose hadn't been in the parking lot for any longer then 10 minutes and people were already starting to pull up waving their dollar bills in their hands. Motioning for Moose to come grab them, handing them back some of his Art in return. Just as he had finished fixing the cardboard signs, a girl walked over handing him a small milkshake. As he thanked her and handed her back a piece of his Art, there was nothing that could taste better than that vanilla shake right then. Moose drinking it, while staring back over at where he had just been locked away for the night, in the cold, lonely cell.

He then looked over towards the Saskatchewan border which lie at the far end of the parking lot and remembered what the officers releasing him, had said. He decides to start pushing the cart back towards the shopping centre on the far west end of town again. Where he was arrested the day before. He could also stop and use some more of his rewards points again to wash the night he spent sleeping on the street and inside the prison cell, off of him.

After passing the mall and getting just a block away from the truck stop, he noticed brad's wife, Jessica outside of the veterinarian clinic. Brad was sitting inside their vehicle, out front of the clinic. Moose walked over, showing them some of his Art. It had been just over a month since he had bought the school bus off Brad. He left them some of his Art, while Jessica was still talking to the vet about her concerns about their dog. He walked back to his shopping cart left on the sidewalk and continued his walk west.

Finally arriving at the truck stop and after another redemption of 50 more of his reward points, he was wheeling his red toolbox through the obstacle course of the store once again. Standing in the shower with his head down and his eyes closed in a state of self meditation while the hot water, ran down over his back. Embracing the sensation of every drop of water running over him, washing the last couple days dirt off, while cleansing his mind. Washing out any negative thoughts and replacing them with positive new ones, focusing on the tasks at hand and what he might encounter over the next few days, hours, weeks or even months. One thing Moose did know was, he had to move the bus by Friday. Which was 2 days from now and he still needed more money to do it, as well as find a place to move it to.

Moose was now back on top of his red toolbox and back at the end of the drive-thru line. The time now was just after 9 P.M. and the shopping hours were ending for the night. The sky, now more of a cloudy grey then the bright blue that had been sticking out of the clouds when he was released earlier. He felt good and ate well that evening, as a few BLT sandwiches still stuck out the back of the shopping cart, inside their brown paper bags.

A lady walked up asking, "Do you take gift cards?" Then handed him a $25 dollar gift card with the receipt taped to the back of it, telling him the one in her hand still had about $30 dollars on it before handing it over to him as well. A man in a new burgundy Ford Mustang pulled up quickly handing him a $50 dollar bill through the driver's window of his car. Moose picking out some of his Art from the red toolbox each time, making sure to give them some of his Art along with his thanks in return, before they drove off.

As the night ended, the last business in the shopping center closed its door's. Moose decided it was time to leave the drive-thru line and head over to the 2 park bench's he had slept at, a few nights earlier. The sky, still a shade of dark grey as night fell wasn't feeling like too much of a threat. Moose not feeling any signs of moisture in the air, layed down on the park bench and fell fast asleep, it had been a long day.

When Moose woke up, the first thoughts that entered his mind were moving the bus that Friday. He had enough money now to move it if he counted the money he'd make with the bottles and cans, back at the storage yard. Moose still had no way of getting them over to the bottle depot. He pictured himself filling a shopping cart and making 7 or 8 trips, pushing them over to the depot. The distance needed to travel between trips making it not much of a feasible option. So, Moose figured he would sit at the shopping cart for another day and night out on the streets of town, calling the storage place first thing in the morning and moving the school bus then. He was sure to have enough money by the end of the day for the move and things should work out fine.

It must have been getting to be almost noon now. The hungry birds of the parking lot, began starting to flock in. Moose, looking up while sitting ontop of the red toolbox began noticing seagulls perched on top of every streetlight in the parking lot, staring down at him. Not sure if they were wanting his sunflower seeds he was eating or could smell the box of timbits sitting inside the shopping cart. Moose stood up grabbing the leftover timbits and left-over food items from the cart. After eating the meat and cheese from the sandwiches, he took the hard sandwich bread, ripped it up into chunks and threw them out in front of him, around the parking lot.

As a few chunks of bread hit the ground, a feeding frenzy would begin. The seagulls flying down and attacking the pieces of bread, playing a game of football with the bread chunks. When one seagull picked a bread chunk up, he'd have to dodge and deke around his opponents who were snapping at him, hoping for a fumble or a chance to snatch the piece of bread out, from the other seagull's beak. When a seagull had made it clear from the flock of attackers he'd fly away for a touch down, where he could enjoy eating the trophy he had just won.

It was always a good time creating flocks of birds in the parking lots as they flew down from the sky, walking short paces back and forth on the pavement in front of him. Hoping to have a piece of food they desired, thrown their way. While feeding the bird's, Moose often shouted out while mocking the voice of a parrot, "Don't feed the birds! Don't feed the birds!"

Another time, after getting annoyed with one of his watchers staring at him in the parking lot and seeing the same guy, in the same truck, in the same spot after a couple days. Moose decided to use his seagull friends to his advantage and

walked by the driver's side of the truck, secretly dropping a handful of cheezies from his hand onto the ground. Instantly the flock of seagulls landed on the ground outside the door of the truck, beginning to squawk away. The man inside the truck quickly rolling up his window and after a few minutes of the birds harassing him, started up his truck and drove away, leaving the parking lot. Moose enjoying all the entertainment while back sitting ontop of his red toolbox, beside the drive thru.

After Moose was done feeding the bird's, he decided to pull out one of the 3 books he had brought with him, one of the books was a black leather Bible he had been given while he was in Leduc that past winter. The other 2 books were, "Make Today Count" and "The 21 Irrefutable Laws of Leadership" He decided to continue reading the book about the Laws of Leadership as the afternoon carried on.

The day was going well, Moose enjoying meeting the people who stopped and talked with him. Sharing smiles and compliments among the thank you's, as they both gave their offerings to each other throughout the day. Only mother nature not liking to play nice, as the wind continued throwing its little slaps of air at Moose or the shopping cart, in its attempts to knock it over onto its side. One slap, being a gush of wind that came out of nowhere taking around 25 pieces of Art with it, sitting on top of the toolbox and scattered them across the far end of the parking lot so fast that Moose wasn't about to chase after them. Each piece taking off in the different direction's the wind had flung them.

Moose starting to feel the strong gusts of wind that were picking up and were soon going to bring the rain it had been brewing up in the sky over the past day.

Getting suited up in his rain gear and pulling out his umbrella, he wasn't about to start worrying about it, move his red toolbox, or the shopping cart. Moose thought if he could work 12 hours on an oil rig in the rain or the freezing cold of winter, he could make it through sitting on top of his red toolbox for the afternoon or the day in the rain, if he had to. He did pull out the contents of the shopping cart making sure to place everything of his into garbage bags. Making sure everything was protected against the rain through the cardboard walls of the cart and kept dry.

The rain fell down in short blasts, the longest downpour lasting no longer than 10-15 minutes. Moose was a little damp, most of it from sweating underneath his rain gear. After about an hour of the on and off downpour, it was over. The parking lot completely soaked with puddles, as people began dodging the large sudden lakes of water on top of the pavement as they exited and returned to their vehicle's.

The cardboard on the shopping cart not looking like it enjoyed the water much either, as half of it started to droop and look much like a soggy toilet paper roll. Half the cardboard attached to the shopping cart was made from a thicker box, it held up a lot stronger then the thinner boxes which seemed to keep dissolving, as the cart slowly kept looking worst. Eventually having to remove most of the soggy cardboard and reinforce the walls that were still left on the cart, from slipping down and folding over.

As it was getting to be almost dinner time now, an Asian man walked over and squatted down in front of Moose while sitting on top of his red toolbox asking him, "Are you hungry? Can I get you something to eat? How about a full roasted

chicken? And drink?" Whatever Moose wanted, the man was offering to go inside the grocery store where he worked and get it for him. Moose said, "A man would have to be crazy, to ever say NO to someone offering him chicken!" as Moose said no to everything else the man was offering, he said, "Chicken and a root beer is plenty, and more than enough! Thank-you!"

The man then walked off towards the grocery store and returned holding a brown bag with a whole BBQ roasted chicken in it. As well as some kind of imported root beer. Holding up the can of pop, Moose said, "This must be the good stuff, the stuff that contains real sugarcane cola." The man then walking off with some Art in his hand before hopping into his vehicle and leaving the parking lot.

Moose placed the brown bag containing the chicken onto the bottom rack of the shopping cart, waiting before pulling the meat off the bird and feasting on the chicken as if he were a barbarian back in medieval times. Washing it down with his sugarcane, cola root beer.

The rain still held back it's second downpour, as the sky was looking very angry behind Moose. He figured he'd walk over a few blocks, towards the McDonalds. Changing up the scenery while breaking up the rest of the day. The day was treating him well besides the bit of rain. I guess life's not always perfect and you can't have one without the other.

Pulling the red toolbox in one hand and the shopping cart in the other he began the walk. Feeling the water squishing around his feet in his worn-out shoes, still without any shoelaces in them. The rest of him was considerably dry for the most part, while under the rain suit and umbrella.

As he entered the next parking lot into the next shopping plaza, he parked the shopping cart and rolled his red toolbox inside the store buying some leather sandals. This pair having toe bumpers to protect your toes in the front. They were also on sale for $29.99 from their regular $49.99. Not finding a size 13 around the shelves of the store and finding out apparently that store location didn't carry any sandals or shoes, larger than size 12. Immediately pulling off his wet shoes and socks and putting the sandals on, as soon as he was back out in the parking lot before continuing with his walk.

After stopping and parking the shopping cart, he began feasting on the BBQ chicken. It tasted amazing and why not try some of his root beer to wash it down. He cracked open the can of root beer taking a huge gulp of it, spitting it out all over the ground! After a full mouthful of the drink, it turned out it wasn't root beer. It was an actual beer, just the .5 percent kind you could buy at the grocery store. Moose didn't drink liquor and the taste was not going well with him, he walked over to McDonalds and enjoyed the $1 dollar drink days.

A few people had pulled up, or looped back around after leaving the drive-thru and had seen him as they left. Waving their $5 dollar bills or closed fists containing any coins they could find lying around their vehicles. A younger east Indian kid walked up wearing a red shirt, handing Moose a zip-lock bag full of an assortment of coins. Some of the coins being from different countries.

A construction truck which turned out to be a couple guys who were roofing for the day, had also pulled up. The passenger looking at Moose, while grabbing the papers off the dash inside the vehicle. He began waving the papers from off the dash as he yelled over, "Do you got anymore of these?" Moose noticing it was

his Art that he was waving around shouted back, "I DO!" The 2 roofers hopped out of the vehicle and began looking at the different pieces of his Art.

One of them handing Moose a $20 dollar bill before grabbing another $20 dollar bill from out of his pocket saying, "I want a couple more of the Art prints for my friend that works in the oilfield and would also love the pictures!" The 2 guys complimenting how awesome the Art was and how they had never seen anything like it before. They were also ex oil-field hands themselves and had previously worked in the oil patch, before their new career paths in construction.

A great feeling of pride came over Moose about his Art and his accomplishments of getting his Art out. All the compliments and positive thoughts that had started coming his way since he began handing it out. Moose thought about all the things he could have been doing with his Art, if he had the proper tool's and money to accomplish his vision's. So many outside forces holding him back from his capabilities, but he had made a significant leap with bringing his Art to print and getting it out there. All while being homeless and suffering the daily torture of the streets. He thought of all the garages, work shops and people's kitchen's or living rooms that were now displaying his Art, over the last week and a-half he had been handing out his Art.

The night soon shortly came to an end, the clouds not looking much nicer since the downpour. Moose needed to get back towards the Wal-Mart before they closed at 11 P.M and quick. Not sure what role the rain played, but the bugs were sure heavy and out in full force since the late afternoon shower. He pushed off with the red toolbox and shopping cart, pulling their weight over the few blocks back over.

As he pulled into the parking lot a small SUV stopped, a Pilipino not much younger than him yelling out, "Hey are you hungry?" from the driver's window of the vehicle. Moose now stopped and was walking over to the open window with a piece of Art for the guy and began explaining he had just ate a whole BBQ chicken a guy had gotten him earlier. The guy continued to persist on going to buy him something to eat. Moose finally said to him, "Do you know what I really need? I was headed to get some bug spray, I need that more than food right now!"

Moose began to worry if the man was going to come back, the store closed in 15 minutes. He thought he'd give it another 5 minutes before heading to the store knowing he couldn't make it through the night if the man didn't come back. 5 Minutes passed and Moose headed off towards the main entrance.

Setting the shopping cart off to one side of the entrance, Moose walked into the store, grabbing a bag of sunflower seeds that were on sale near the front entrance. As he began trying to spot the guy that had went on the hunt for bug spray, he noticed him at one of the self check outs. He walked over to him to let him know he was in the store now. After showing Moose the bug spray and making sure he had the right one, he payed for the bugspray and the sunflower seeds. Moose thanking him while pulling out the can and starting to spray a cloud of bug spray over him. Finally, having a break from the insects that wouldn't stop landing on him after the rain that day.

Back outside, the clouds didn't look very good as he laid down on top one of the park benches. Neither did the wet concrete sidewalks, beneath them. He didn't have any trouble falling asleep that night either, as the music played from inside his red toolbox.

When Moose awoke and the night had turned back into day. It greeted him with the same grey cloudy skies and dampness as the night before, only raining a light mist down while Moose slept. The surface of his sleeping bag was damp as he crawled out of his sleeping bag, somehow managing to stay dry through the night.

Moose, figured he'd push off back to his spot at the drive-thru and then call the storage yard when they opened at 9 A.M. and get ready for the work involved with the big move. He still wasn't sure where he was going to move the bus. He had a few idea's, just not the time or mental energy to begin looking if the search didn't start going well or started to feel doubtful.

The shopping cart was definitely in need of a new make-over, as the dampness through the night had now taken any support left in the wet cardboard. Making it now appear to look like the cardboard was melting, as the extra weight of the water soaked into the cardboard, bringing it down to it's knees. Moose figured he could make it work until he got a hold of the storage yard, it was only a few hour's away until they opened the office that morning.

A lady pulled up handing him a breakfast sandwich on her way to work for the day. As a guy in a jacked-up truck pulled up handing him a $20 dollar bill and a coffee. They shared a short conversation about the crash of the world oil price, while staring into the Art that showcased an oil rig, Moose had worked on in the past.

It was a quiet morning and he had made enough to move the school bus. Now, it was just trying to move the bus and take in the cans and bottles he was offered.

He could use the extra cash and didn't want to have to leave them behind in the dump trailer back at the storage yard.

Moose figured it must be around 9 by now, anxious to get back out to his school bus he decided to check the time. His phone saying it was just pass 9 A.M. as he began to look up the phone number, saved in his contacts for the storage yard. After hitting the green call button, to Moose's confusion there was no answer. Thinking it was kinda odd someone wasn't answering the phone after 9 A.M. he called again and there was still no answer. Looking puzzled at his phone, waiting for it to tell him the answer that he was looking for, he decided to open google maps and above the phone number where the hours of operation were. In bold black letters it said, "**Closed.**"

Well, the phone did gave him his answer. It wasn't Friday, it was actually Saturday, and the office was closed over the weekend. Moose didn't put too much thought into it, he didn't have the money to move the bus the day before, anyhow. He would now have to wait until Monday to move the school bus out of storage. It would also allow him to get some more cash together for the move and maybe find a new home for it as well, over the weekend.

With the thoughts he had for the day moving forward or being back at the school bus quickly being replaced with new ones, Moose now had to make a mental map, making a new plan for the weekend ahead with the cart. Hoping mostly for mother natures forgiveness on him, over the next couple nights being outside.

The shopping cart would definitely have to be rebuilt, as the soggy cardboard hanging off it didn't look too healthy now and wouldn't make it through the next

couple days or even make it through a couple more hours on the cart. Moose had an idea and headed over towards one of the stores, leaving the shopping cart in one of the parking stall's out front.

He walked in pulling his red toolbox behind him and returned after buying a box of brochure paper to print more Art. Also buying all the square chunks of plastic waffle board that they had, 4 square pieces at $10 dollars each and a set of letter stencils. Spending nearly half of his money by the time he had walked back out of the store.

Then he walked over to the store next door and bought 3 cans of spray paint. Afterwards heading to the Dollarama and this time buying many zip-ties and the glass lantern to place his porcelain angel in. She needed the protection after all the close calls she had in the past. Her candles inside the glass house would also make it alot more difficult for the wind to blow out. Also getting a lantern or planter holder, that her new glass house could hang from.

He figured the money spent on the new sign was going to save the cost's and time spent in painting and replacing the cardboard in the long run. Moose's ultimate goal was to make a sign that was waterproof, but also something he would be able to assemble and dismantle from the shopping cart in minutes, if needed. Moose also thought after the new sign was built, he'd have no problem making the money again to move the bus.

After leaving the Dollarama, Moose headed off down the alley to where he first set-up the cart, remembering again about the stolen stencils he had taken the time to cut and never got to use.

He decided to stop along a big patch of grass and started laying out the plastic board squares. Looking at the squares layed out in the grass and then back at the shopping cart trying to envision what the sign might look like when it was finished. Moose, decided to just start painting the words of the sign onto the plastic boards, using the stencils he had just bought. He painted the first 2 sets of words and then ran out space on the plastic boards to finish painting the rest of the letters on.

While he was painting the letters on the plastic boards and thinking of the possibilities that he could do with making the sign, a silver Mercedes sports car pulled up in the alley next to him. A young kid maybe in his early twenty's getting out of the car shouting, "Hey, are you the guy with the Art?" Moose stopped what he was doing, flipping the lid of his red toolbox open.

How about we just call the, "Red Toolbox" the, "Artbox" from here on, "Moose's Artbox!"

So yes, where were we? Oh yes, after flipping the lid of his Artbox and pulling out one of his favorite Art prints he had first created, he handed it over to the young kid that had a $5 dollar bill ready in his hand to give him. After a quick thank you between them, the kid jumped back into his car and drove out of the alley. Moose looking back down at his plastic boards layed out in the grass. "This isn't going to work!" he said to himself as he gathered everything up and headed off further down the alley.

He pushed all the way up across the street and up past a few other shops along the row of the power centre. Finally pulling up in-front of the arts and crafts store, to see what they might have for plastic waffle boards like the ones he had just

bought. After buying a stack of black plastic boards he had $20 dollars left in his wallet. With everything Moose thought he needed, he left and headed around back and found a wide-open space of pavement, behind the building. The feeling of rain in the air, wanting to come down at any moment.

Moose figured he'd create something like a sheet, that would hang over the shopping cart. It would also be able to fold up and stack neatly. Folding over and under each other, back into a single square. He started to spray the last 2 sets of words onto the plastic boards, seeing the vision of the new sign he wanted, coming to light. He began poking holes with a knife, making slits up and down the edges of the plastic squares where they were to fold together. Then putting zip-ties into each slit that he had just cut, joined the zip-ties together with a third zip-tie, connecting everything.

While out behind the arts and crafts store and putting together the unusual sign for the shopping cart, one of the staff members came out in her red Michaels vest and threw some items into the garbage bins out back. Curious to see what Moose was up to, she walked over and chatted quickly before running back into work. Heading back into work with a piece of his Art in her hand.

Now, starting to run out of zip-ties with the mass amount needed for the project, he started to think of how he could get to the dollar store on the other side without anyone disturbing his things while he was gone. When suddenly, an older car pulls up to the corner where he had everything spread out over the ground. The lady he had just talked with from the arts and crafts store had just finished work saying to Moose, "I don't know what your medium is, but I got you these!" Handing him a giant pad of art paper, a box of marker's and a box of

pencil crayons just before pulling her wallet from her purse, handing him $40 dollars. Moose handing her one of every Art print he had from inside his Artbox.

Then not that she hadn't done enough for Moose already, he asked her if she could run to the dollar store quick to grab a few things of zip-ties for him, if he was to give her the money. Refusing to take his money, she backed out from where they were and sped off to the front side of the dollar store. Soon to be back with 4 packs of zip-ties and one of Moose's favorites, Hawkins Cheezies.

After burning most of the zip-ties, he started to realize that he was going to need more of the plastic boards for the sign. He decided to gather his things up and not risk something like the stencils he had bought this time to go missing. He packed everything up to go get the final things that he needed. Stopping at the dollar store first to get more zip-ties. This time more than enough so he wasn't running out of them again.

When he got to the door for the arts and crafts store it was locked. Apparently due to covid-19 they closed at 5 P.M. on the weekends, his cellphone reading 5:35 P.M. He would have to wait until tomorrow to finish building the sign he was creating. He also had only one more day to make back the money he had just spent, to move the bus the morning after.

After spending hours only getting one side of the sign finished and attached back onto the shopping cart, he decided to head back to his spot at the end of the drive thru. Stopping along the way to put on his bright orange rain suit as the sky was starting to spit its random raindrops down on to him. Thinking the rain wasn't going to let up at all when he got to the drive-thru, he decided to keep on walking. He made it a few block's and found himself back over at the McDonald's.

The Original Joes next door had a slight overhang that would keep him dry while he sat on top of his Artbox. The shopping cart however, would have to suffer and be left out in the rain for abit. It would make a good test for the new plastic boards that the cart now wore.

It was now night again as everything was starting to close. It had been a quiet, wet evening since the late afternoon. Everyone staying in and out of the rain. Moose thought he better find some real shelter for the night. Walking down another 2 blocks he pulled up in-front of an Asian cuisine restaurant, with a bright red and yellow sign that read, "Touch of Asia" hanging in front of the business. It had a large overhang above the front windows that covered a large enough area for him and the shopping cart to stay dry.

After pulling everything up and under the overhang he laid down his sleeping bag that was still damp from the night before. Moose sat back staring at the new sign attached to the shopping cart. The cart looked pretty good, having only one side hanging on it.

The porcelain angel looked amazing, sitting in the middle of her new glass home. The flickering of her candlelight's reflecting off the glass walls surrounding her. The glass house, hanging out in-front of the shopping cart by the garden hanger that Moose had gotten earlier. Now as the angel hung out in-front of the shopping cart she would lead the way, most importantly, she would keep the light shining on the road ahead.

5

Waking up to daylight, while drifting in and out of sleep, Moose didn't get up until close to 9. Beginning his trek 7 or 8 blocks, back to get the last of the plastic boards he needed to finish the sign. Along the way, he was stopped by a lady in a silver SUV stopping to hand him $40 dollars, as he began looking to find her some Art from the Artbox in the middle of the road. It'd be a quick exchange of thank you's before she'd have to keep driving as someone had quickly pulled up behind her.

After buying the last few plastic boards he needed, he dragged his things around to the back of the store. He layed out the sign he on top of the pavement again and laid down the plastic board squares he had just bought creating a larger rectangular square. It was a beautiful sunny day, after the downpour of rain from the night before. Wasting no time in beginning to spray paint the letters needed, for the double-sided sign onto the plastic boards.

After he was done painting, he finished joining all 14 of the plastic boards with the zip-ties so they all were connected into one. He then threw the sheet of plastic boards over the cart like a blanket, letting each side drape down over the cart. The sign held up in the middle by the steel wire garden fences he had zip-tied together, making a frame strong enough to support it over the cart.

Moose grabbed one of his bungee cords that had a steel carabiner hook on each end, clipped one end onto the steel basket of the shopping cart lifting the plastic boards up off the ground, Folding them up, before clipping it onto the other side of the shopping cart. He did the same for the other row of plastic

squares, clipping the carabiner onto the shopping cart before stretching it across and clipping the other end.

After 2 bungee cords and both sides of the cart folded up, the word's, "GOD-BLESS" Read out across each side of the cart in white letters, shining off the black plastic boards. The words. "PLEASE HELP! SPARE CHANGE?" that read out above the words, "GOD BLESS" now hidden beneath the folded plastic boards.

What a beautiful cart Moose thought, as the angel hung in her glass house with the words, "GOD BLESS" stretched out across each side, behind her. Moose decided to name the porcelain angel, "GOD-BLESS" as, "The GOD-BLESS cart" was now born.

Getting to be almost about noon now and the sign for the shopping cart now complete, Moose figured he'd better get over to the drive-thru and start making back the money he still needed to move the bus the next morning. 5 minutes later, he was back parked at the end of the drive-thru line.

If Moose was looking for attention, the new sign he just made was sure getting it. People's heads turning in their vehicles and as they walked, to and from their vehicles from anyone who happened to catch a glimpse of it. The shopping cart was definitely not hard to miss, the letters of the sign easy to read from across the parking lot.

A few ladies pulled up asking, "What is this?" or, "What's the shopping cart all about?" An older gentleman also pulling up asking, "So, what's your story?" The shopping cart was attracting huge attention, as people drove by or left the drive-thru line. Some with their cellphones held out in front of them, pointed over towards the unusual shopping cart, no one had ever seen before.

Overall, Moose was pretty happy and impressed with his new sign he had just built. The shopping cart definitely stuck out and was a big step up from the cardboard walls he had built for the cart before. The rain that came down since he had made the sign, did nothing but splash off as the raindrops slid down the plastic. Moose thought the sign was a success for what he was trying to achieve and enjoyed watching the reactions of people face's as they drove by, whenever the cart caught their eye.

Throughout the day while sitting on top of his Artbox, he'd stare off at, The GOD-BLESS cart, admiring his work. Enjoying, hearing the compliments from those coming up to see the shopping cart and had thrown their change into one of his silver pails. Moose began thinking of the possibilities the new sign could give him now, traveling anywhere with him and assembling it onto any shopping cart within minutes.

The people must have really liked the new look of the shopping cart. It had been a great day. The sun shined all day and he had more than enough again to move the school bus in the morning. As the Sunday night at the power centre began to die out, Moose began revising his plan until the storage yard opened in the morning.

The ugly clouds continued to roll in as night fell, he decided to push the cart across town with his things inside, to the front gates of the storage yard. Roughing it out there, until morning when he could call the office and have the front gate opened. Thinking he could always sneak in a few hours sleep at the bus before he moved it, or until someone came and woke him up.

It was just after 9 P.M. as he began walking away from the drive thru and left the parking lot with his 2 new friends beside him, GOD-BLESS and his Artbox. Starting the long walk towards the storage yard along the highway that ran just outside, the outskirts of town. It wasn't far up the road and Moose had already started to think about turning back.

The highway completely black, hiding the sudden attack of mosquitos and flying insect's as he walked down into the countryside. Soon crossing over a set of railroad track's, stopping to take a quick picture of GOD-BLESS glowing in her glass house on the train tracks, under the moonlight.

While Moose was stopped at the railroad tracks, the bright LED headlights of someone's vehicle had now turned down the highway towards him. Moose thought he better get off the tracks and get The GOD-BLESS cart and himself to the shoulder of the pitch-black highway, as a truck with its jet exhaust roared by him. Moose continued down the highway for a little longer and soon seen streetlights for the intersection into the new industrial part of town, containing mostly vacant lot's.

When he finally got to the turn, he was happy to see a bike path on the far side of the street and quickly got the cart and Artbox onto the trail of smooth fresh asphalt. Now, not having to worry about any vehicles, or being in the way of any pedestrians out there at that time on a Sunday night, he continued for a few blocks passing by the vacant lot's that ran along each side of the wide pedestrian path. Seeing the Kenworth shop ahead he decided to stop and have a break there, charging his cellphone at one of the plugs that were out front. Sitting down beside the plug on a park bench along the front wall of the large building. He was over

half-way to the storage yard, but the walk down the dark highway took its toll on him and his leather sandals.

After charging his cellphone for an hour, the night wasn't looking much nicer up above, as he decided to make the final stretch up to the storage yard. He only had the corner of the truck route left to walk before turning left at the S.P.C.A. Then it was only a couple kilometers down the range road.

When he got to the S.P.C.A. Moose stopped and stood under the last streetlight that bordered the town from the countryside and its complete darkness. Thinking of the bugs and the unknown hiding in the dark night, he wasn't about to walk any further down the road. Across the street to his right, he seen a huge white steel cross. The cross must have stood 4 feet tall off the ground.

Moose parked the shopping cart overlooking the cross from up on the gravel road behind it and walked down the narrow-manicured trail that led to a small clearing around the cross. The small grass clearing being very well-kept and maintained. The much longer grass of the ditch and fields held back from whoever must come down to visit Niki, the name that was across the middle of the cross. There were small patches of flowers around the cross, and there was a small iron, wooden garden bench for the visitors that came to visit Niki. Moose grabbed his sleeping bag and a couple mosquito coils from the cart, laying down in front of the cross. It was just Moose, Niki and GOD-BLESS in the darkness of the countryside. GOD-BLESS's candle's flickering away as she kept watch over them that night.

As the sky turned from darkness to the colours of day again, he kept waking up briefly before going back to sleep, enjoying the peaceful sleep out on the grass in the countryside. He was in no rush to start the day and move the bus. Moose feeling much like a lazy lion that wanted to lay around and sleep, before playing his role in the jungle.

He was soon awakened to a shout, "Hey, are you alive?" as an R.C.M.P. member was standing at the door of his police cruiser parked alongside the range road. Moose starting to get to his feet. "Yea, I'm fine, you could have at least brought me a coffee!" He yelled over to the officer, followed with, "You guys just released me a few days ago! I'm going to move my school bus today!" The officer replying, "Well, you still have your Yorkton matter to deal with. I'm not going to arrest you, we're on the Alberta side but I could meet you over on the Saskatchewan side if you wanted to deal with it?" Moose then making the suggestion to leave his thing's there and just have him drive over to the Saskatchewan side, it was only a 2-minute drive away. Moose went and sat in the back seat and they started driving over to the Saskatchewan side of the border, just down the road. His Artbox sitting next to GOD-BLESS as she kept watch of it, while they were left alone on the gravel road while Moose went to go deal with his matter.

When they got to the right side of the border, the officer had his partner drive out and bring him the proper paperwork for Moose to sign, with the new court dates on them. It wasn't long and they were back on their way to the Alberta side of the border. Moose, dropped back off at his Artbox and GOD-BLESS, as the officer drove away.

After the police cruiser was gone, Moose pulled out his cellphone and called the office of the storage yard. Everything was good and he was smiling knowing in a few minute's he was going to be back at his bus again, nothing and no one could come in the way of that now. Walking away from the tall white cross he said, "Goodbye!" to Niki and then headed off towards the storage yard.

Moose, punched his access code into the little box at the front of the main gate, the gate sliding open this time. He got a few feet into the yard when one of the jacked-up trucks with the loud exhaust tips, pulled in beside him. "Are you supposed to be in here?" The man shouting out from the truck. Like he didn't just see Moose punch in his code and obviously the gate just opened for him. Moose noticing the driver was one of the officers from the detachment, when he had been released a few days earlier, now sitting in the truck yelling at him in civilian clothes. Moose yelled back at him, "Are you supposed to be in here? I didn't see you punch a code in when you sneaked in behind me?" "Yeah I got a code, there's just a lot of crime in the area, people taking pickers and stealing whole shipping containers!" the officer in civilian clothes saying.

Moose didn't have time for his harassment, or games, or both. He started pulling The GOD-BLESS cart and the Artbox down the stretch past the shipping containers towards the school bus. The truck was now sitting in front of the gate, trying to get out. Moose stopped his walk down the road to the bus, turning around and walking back towards the gate, punching his code in to let the truck that had pulled in to harass him, back out of the storage yard. Moose was used to the constant harassment, but he was sure getting tired of it.

Finally, back at his school bus again he opened the front and back doors, letting the fresh air flow through. After starting up the generator, he sat down in his office chair in front of the desk, turned the fan on and took a moment to himself. Closing his eyes, enjoying the refreshing, cool air being blown over him.

Moose was still not sure where he was going to move the bus that day, while sitting back in the office chair, looking around at everything and getting his mind thinking. Worst case, he could always park it among the rigs and tractor trailers at the truck stop.

Moose decided he better get started calling around for a tow truck and get that arranged. A man named John, answered the other end of the phone. John had a truck out in Lashburn at the moment and told Moose he'd call him back after he had talked with the driver. John, with the towing company called back, "My truck can pick you up on his way back from Lashburn in about an hour and if your not sure where you want to park it, I was going to suggest to you, you could park it over at my place out on range road 14 until you figure out what your doing with it, and I won't charge you anything for storing it out there!"

If the tow truck was going to be there in an hour, Moose thought he better hurry up and get what he needed done before the truck showed up. Now, the bus was probably going to go out to Johns place. Moose went outside and looked at the bottles and cans he didn't want to have to leave behind. He decided to clear up an area inside the bus and take the bottles and cans with him. He started by moving his bedding that was layed out on the floor and laid out one of his big tarps. Beginning to fill the bus with the cans and bottles from the dump trailer, that sat next to the bus.

Moments after getting everything tucked away into the bus his phone rang. The driver of the tow truck had just pulled up to the gate. Moose began walking towards the gate, punching in his code in and hopped in the passenger seat of the tow truck. After a quick hook up to the school buses rear axel, they pulled out of the storage yard and were now off to John's place. Hanging a right, across from the large white cross and then heading west, away from town.

It was about a 5-minute drive out to John's place on range road 14 from there. The tow truck dropping the school bus along a row of trees that bordered John's property. The driver of the tow truck asking him what his plan was or if he needed a ride? Moose decided to stay at the bus, he had work to do.

First, he started with unloading all the bottles and cans into a pile outside the bus. Then he took out the generator. Starting the generator, giving the school bus life again and began to organize his desk area. Making new Art prints from his collection of old photos he had stored on various hard drives and usb sticks. While the printer, printed multiple copies of the new print, he just made.

Moose now had a plan. He was going to head out towards Edmonton with the Artbox full of Art and his new travel friendly sign, going on an Art fundraiser. Hopefully making enough money to finish the renovations of the bus, with hopes of buying a woodstove to get through the winter months. The school bus would be safe out at John's for a couple weeks while he did this and hopefully, he could have it moved out to the seasonal lot finding a permanent home for it when he got back from the fundraiser. If all went well, the worries of winter or the second wave of the pandemic hitting would not be a worry on Moose's mind.

Suddenly, the printer threw up an error code up and stopped printing. Moose had just replaced the slide with fresh paper. After getting no answer's and the printer still showing the error code. Moose finally decided to get some sleep, laying down where all the bags of bottles and cans had just been during his ride over in the tow truck. As Moose layed there, he began to start visioning and thinking of the journey he was to head on, with his Art and GOD-BLESS over the next couple weeks. Thinking of all the outcomes and problem's that could arise along the way.

Waking up the next morning, to the sound of the generator that had been running through the night. Now with his new plan, he started getting ready for what he would need to take on the trip and get the bus a little more organized.

First though, Moose would have to go to town and make enough money to get a new printer. The printer he had cost $299.99. He already had spare bottles of ink he ordered off eBay at a discount price to fill the tanks of the printer. One fill of the tanks was equal to 80 cartridges on a regular printer. That was a huge savings when 1 cartridge could cost you up to $80 dollars alone. He saved thousands of dollars, and when you're printing high quality print's, the printer loves to drink the ink. He had enough for the printer with all the bottle's and can's that were sitting outside the bus. They still weren't an option though, he still had no way to transport them for a refund at the bottle depot.

It wasn't long after and John was calling Moose asking, "Hey, are you staying out there in the bus?" "I stayed there last night, I was printing pictures!" Moose answered before going on to tell him that he was thinking about going to Edmonton for a couple weeks. John finished the call saying he didn't want any

issues with the county, for someone staying out there because of zoning issues and what not.

 Shortly after his talk with John, Moose was pulling his Artbox with his sign strapped on top, walking into town. As he walked, he had pictures of Art running through his mind, mental mapping the big journey ahead. He also pictured how he was going to make the long walk back to the bus, with the new printer box sitting on top of the Artbox.

 After a half hour of walking south on range road 14, he finally got to the Yellowhead highway, taking a left towards town. Another half hour of walking before entering town right near his favorite spot, at the end of the drive-thru line.

 As Moose arrived in town, his immediate task was to find a shopping cart and begin assembling, The GOD-BLESS cart. After a dozen zip-ties, the cart was back together. After getting the cart back over to the drive-thru, people were pulling up with their offerings of cash, as Moose handed them back his Art in return. Watching them having difficulty taking their eye's off the Art as they held it, driving away.

 Not long after arriving at the drive thru, he walked over to look at the new printers. They had his printer showcased sitting next to its big brother version, which had a $550 dollar tag on it. Seeing no boxes where his model was to be, he asked a sales associate. The sales associate, finding one on a top shelf near the back of the store. After bringing the large box down he carried it to the front, customer service desk. Moose not having enough money for it yet, asked about their lay away plan. The manager saying, he'd hold it for him until closing time.

They wrote his name and phone number down on a post-it and set it behind the front counter, until he could make his way back to pay for it.

They closed at 5 P.M. with their new covid-19 store hours enforced. A couple hours had passed and during the last minutes before the store was to close, Moose ran back over. Noticing they had also restocked the packs of high gloss brochure paper. Not having enough for the printer, he asked for an extension until tomorrow, to pick up the printer. Also spending $150 dollars he had on 600 sheets of brochure paper. Now, after finishing the grind for his new printer, he would be set with everything he needed for his road trip and have more than enough Art for the big journey ahead.

Right now, he needed to start thinking where he was going to spend the night outside. He figured he'd walk the cart across town to the east side, where he had slept at the ball diamonds the week earlier. Stopping again for a much needed shower again, along the way. After folding the plastic boards up and off the ground, he began his walk.

After stopping for a few minutes here and there, He got to the far side of town in just under a couple hours. Stopping for his shower and best of all, no cart tip overs along the way. Just a few ankle nips from the cart as it sometimes slid in behind him, snapping at his heels.

It was just after 8 P.M. and Moose had finally got to the other side of town. He had made about $100 dollars after buying the printing paper and getting the other $200 dollars before Staples closed the following day shouldn't be an issue. Not much happening for the rest of the night, just the sky's usual threatening bolts of lightning, off in the distance, once again. Not fearing any rain to come,

Moose laid down in the corner of a vacant parking stall in front of the oil change business. The candle inside the glass house, dancing out towards the entrance that joined the two parking lots.

He was right about the rain, only a few mere drops splashed down on him through the night. Waking up and opening his eyes to a beautiful, sunny day out, with just enough of a breeze to keep from overheating in the sunshine of the day. Also waking up to a couple people that had brought him a coffee and a muffin with breakfast sandwiches, as they put coins into the silver pail's hanging on the front of the shopping cart.

It was getting to be around noon, he figured he should have enough money to buy the new printer by mid-afternoon. After making enough for the printer he began folding up the flaps, that hung down each side of the cart. With only the words GOD-BLESS stretched out across again, he grabbed the cart and his Artbox and pushed off starting his trek back across town to go pick up his printer that he had waiting for him.

While walking by the truck stop, the option of having a second shower in 2 days popped into his mind. Moose anxious to get the printer and the relief he'd feel of having it, walked right by the truck stop continuing on his way.

When he got to the store, the sales associate grabbed the printer back off the shelf. Moose, now confused why it was on the shelf, finds out that apparently, they weren't holding it for him anymore and had put it back. Happy they still had it, he started to pay for it having enough in bills to cover $200 dollars. Then pulled out a big zip-lock bag of change to pay for the remainder in coins. After he walked

back outside, he placed the printer under the flaps of the shopping cart. He now had a brand-new printer and had all the paper he needed for his trip.

He pulled out his cellphone and called John asking if it was Ok if he was to head out to the bus and stay the night out there, getting his Art prints ready for the trip. John, thanking Moose for the heads up, said it would be alright with him if Moose wanted to spend the night out there. Having enough coins left over to cover a taxi ride back to the bus, he called a taxi.

Minute's after finishing snipping the dozen zip-ties holding GOD-BLESS and the sign to the cart, the taxi rolled up beside him. He pushed the bare shopping cart over to the rest of the empty shopping carts in the parking lot and then hopped in the taxi heading west out of town. 5 minutes later, Moose was back at his school bus with his new printer.

During the ride out, Moose mentioned to the driver hr had a bunch of bottles and cans that he needed to take in. When they got to the bus, the driver looked at the mountain of garbage bags sitting outside. Saying he had a friend that had a van big enough to fit all the bags and could help him take them in to the bottle depot in the morning. After paying the driver with 200 dimes he had counted in a plastic bag. The taxi driver sent Moose a text with his buddy's number that owned the van.

Now, with the taxi paid and gone, Moose began unloading the generator, getting it fired up. Then Moose began a routine, quick organization of his desk inside the bus to make room for the new printer. While lifting the old printer off the desk, he noticed a pen had fell into the paper shoot, which must have happened when he was reloading the paper. After extracting it out and testing

the printer, it was no good. Leaving huge lines across the paper. So, Moose unpacked the new printer, set it up and resumed printing. He had alot of paper to print for the big trip. Moose turned on his tea kettle and let the new printer run all night. Even while he slept, the printer ran until it was out of paper.

Drinking chai tea and printing Art prints until late in the morning, he still was up relatively early around 9 A.M. calling the taxi driver's friend, with the big cargo van. As the van got close to the bus and was on the range road, Moose went out to the road to meet him. Then, quickly loaded up all the bags of cans and bottles into the back of the van. To his amazement, they all fit into the back of the white van, with a little room still left over. After locking up the bus, he finally was heading towards the bottle depot. They'd make a quick stop along the way at the storage yard, picking up the shopping cart that was left behind the last time he moved the bus.

When they arrived at the bottle depot there was a short line outside, just a few people holding a few bags. Moose had the driver back up to the front door, thinking with his mountain of bags, he'd just pile them all in front of the front doors and figure it out then. After finishing unloading the mountain of bags containing the empty's, it was his turn at the far end of the bottle counters.

He had help from two employees bringing in all the bags. The first counter began counting the pile of empty's Moose had made by dumping out a few bags in front of the counter. This bottle depot had a LCD screen showing you the total you were to receive back as the counters counted. It got to just over $200 dollars, before another counter came to relieve the first counter, continuing the attack on the pile of empties out front of them. After the screen read over $400 dollars,

there were only a few bags left to count. The total amount for the huge bottle return was $460 dollars.

Moose handed $40 dollars to each of the two workers that counted the huge number of bottles and left the depot. Then he handed the man in the white cargo van $100 dollars for the ride to deposit them, leaving him with $280 dollars in his pocket.

Walking away from the bottle depot, he was in the industrial park on the far north side of town. He brought one of his Art portfolios with him that had some of his new prints inside. Knowing the shop where he had worked on a service rig in the past, was just around the corner. One of their rigs were in some of his Art. Moose decided he'd stop in and say, "Hi!" to the boys and leave some of his Art with them, at the shop.

After leaving the shop, Moose carried on walking towards the power centre which was still about a half hour, walk away. Along the way he called a few places inquiring about their prices on futon's. He also called the storage yard again, letting the man who answered the phone know, that he went and removed the shopping cart he had left, pushed up against the fence.

After leaving Wal-Mart with a few cases of bottled water and a BBQ roast chicken along with a new futon he called the taxi from the night before. The cabbie that gave him the number for the white cargo van that helped him with the bottle return. After trying to get the large futon box into the back of the taxi, they left it sticking out of the trunk. Leaving the trunk open for the short distance, back out to range road 14.

Moose began setting up the futon after getting the printer, printing again. Also getting everything else he needed together for the trip. This time when he left the bus, he would be off on his big journey. Moose figured he'd be gone for at least 2 week's and who knows where he'd be during those 2 weeks or what could happen.

It was getting late in the afternoon, the futon was set-up and the printer still was shooting out prints. When Moose had a visitor come running up into the bus, through the open front doors. His daughter Mya had came out to visit for an hour, her mother had just dropped her off. Moose showed her some of the Art he was working on and then they did some finger painting. Afterwards he'd scan the Art made from the finger painting onto the computer and digitally enhance it into some cool, neat looking pieces of Art.

After his daughter left, he continued to print onto every good premium piece of paper he had and continued getting himself ready for the big journey ahead. Finally getting tired and laying down, enjoying a sleep on the new futon for a night before the big journey. That was about to begin when he awoke.

Having such a great sleep on the new bed he didn't realize it was already noon when he woke. He only told John he was going to stay out at the bus for one night, so Moose wasn't surprised to see John come up the front doors of the bus shortly after he woke up. John, just interested to know what the plan was and if or when, Moose was leaving. After John hopped in his tow truck and left, Moose left shortly after as well, he just had a few print's left to come out of the printer and the Artbox would be full of Art.

As Moose was saying, "Good-bye" to the school bus, he locked it up and headed down the range road starting his walk to town. The range road has just been covered with a fresh layer of hot oil, as it began sticking to the bottom of his feet and sticking to the rubber wheels of the Artbox. Moose felt like he was pulling apart a peanut butter sandwich with each step he took across the sticky tar road.

Just as Moose got to the end of the range road where it met the Yellowhead, a man in a white utility van that had just passed him a few minutes earlier, stopped. Unrolling his window and asked him if he needed a ride? "I'd love a ride!" Moose replied, just before loading the Artbox and his things into the back of the white utility van. Moose handed the man a few pieces of Art after getting dropped off at the shopping centre, when they got into town.

After grabbing a random, runaway shopping cart and he had finished the assembly of attaching GOD-BLESS to the front of the cart. As well as connecting the dozen zip-ties to hold everything together, he was parked back at the end of the drive-thru line, once again.

It turned out to be a nice evening, the skies still being nice and clear. Moose sat out on top of his Artbox, eating sunflower seed's and reading more of his, "21 laws of Leadership" book thinking about the days ahead. That was when he wasn't running up to someone's vehicle window with a piece of Art in his hands, as he responded to the waves directed towards him, to come their way. Hanging out at the drive-thru for most of the evening.

All the thought's and possibilities of the road trip ahead still ran through his mind. Also mixed with the negative thought's about, if it was the right thing to do? Almost having him start to doubt himself and the trip.

Ready to retreat for the night, he found himself back at the familiar red and yellow, "Touch of Asia" sign, he had fell asleep under before. Deciding it would be a good place to hang his head for the night, he laid down into his sleeping bag. GOD-BLESS looking out towards the Yellowhead, watching the traffic heading east and west, blessing each vehicle with the flickers of her candle.

6

The next morning, he woke up to the most disturbing, annoying sound ever. Appearing to be coming from a semi-truck that was parked across the

street. Having no choice but to get up and leave early, he began his pull down the streets of town just after 5:30 A.M in the morning. Still quite tired he decided to just pull up to a rock island in the parking lot across from the drive thru. Throwing his sleeping bag down on the curb, closing his eye's and falling back to sleep instantly.

Opening his eyes next, to a man setting a coffee and a breakfast sandwich down on top the Artbox saying, "I got this for you!" A lady shortly after saying, "I want to give you some money!" as she placed a $5 dollar bill folded up in her hand into the silver bucket hanging on the front of the cart.

The next time he woke up it was to a, "Hello there? Are you alive?" His first thought was police as he opened his eyes. Moose was right, as he now seen an officer in uniform standing not far from him. Moose beginning to have déjà vu, seeing the same officer that had woken him up while sleeping out at the big white cross a week ago. "Someone brought you a pie! And a loaf of bread!" The officer said, as Moose now noticed the blueberry pie sitting ontop of his Artbox. The officer asking, "So, what's your plan's now? People are phoning in concerned about your well-being!" Moose told the officer, "I'm getting on a bus at noon and going to Edmonton!" While handing him his photo i.d. Moose now awaiting his fate with his freedom once again. The police officer stepped back out of his car saying, "You're all good! But you have to leave this spot!"

He figured he had made enough money to cover his bus ticket and still have a few bucks left over when he got there. The bus was due to leave in a couple hours, and thought it probably be best just to get cart disassembled, folded up and get everything in order. If he had any time left over, maybe a quick shower

before the bus left. The shower in the truck stop, being only across the street from where the shuttle bus was to depart to Edmonton.

The officer waited around until after the cart was disassembled and Moose had began walking away from the parking lot. Before leaving, he asked the officer for a ride over to the truck stop. After getting not much of an response, he began walking to wait the hour before the shuttle bus arrived for their departure.

The shuttle bus pulled into the Shell gas station right on schedule for its city-bound departure. After loading up his thing's into the back of the bus, he boarded the shuttle bus. Grabbing an empty seat near the back and putting on his bluetooth headphones. Fading back into the seat for the two and a half hours to the city.

A couple hours later, the bus was turning into the exit lane and pulling up next to a Tim Horton's that accompanied the Flying J truck stop in Sherwood Park. It was mid-afternoon about 3 P.M. The sun was out and hot, it was definitely one of the hottest days he had felt this summer. Maybe summer had finally arrived.

Moose thought he'd just get out in Sherwood Park, saving the headaches that Edmonton usually had waiting for him. He then started heading south towards the busy shopping strip that ran along one of the main streets near the city center.

In one of his previous lifes, one where he once felt like the Robin Hood of the 21st century, rolling into Sherwood Park on his iron horse were long gone, and never to be felt again. He was now trying to work his way back out of the hole of karma that he had fell into. Now, continuing down the right path and keeping both feet planted on his new path, from here on.

He had only made it down a few block's from where he had got off the shuttle bus, as the sweat was already starting to run down his forehead. Wiping it off using the back of his hand, before running down behind his sunglasses. Everything strapped on top of the Artbox, made it feel much heavier than it usually did as he pulled it down the sidewalk. Not sure how much farther he could make it up the road, he decided to stop at the bus stop, just ahead. Pulling out his cellphone and opening Google maps to see how much further up the road he still had to walk. He had only walked halfway and was actually alot further up the road than he thought. He decided to start looking for some change and wait for the Strathacona transit bus, hopping a ride the rest of the way.

The city transit bus soon pulled up to the bus stop, the driver somewhat speechless for the first few seconds as Moose awkwardly makes a few trip's in and out of the bus while bringing his belongings aboard. "How much is it?" Moose asked the driver as she replied, "Where are you going? Edmonton? $3 dollars and fifty cents!" After he dropped the coins into her ticket tank at the front of the bus, he sat down as a breeze of cool air started to come in through the open windows. Immediately happy that he chose to stop and catch the bus then keep on with the walk in the intense heat the sun was throwing.

Just before the city bus was to arrive at the Strathacona bus terminal, Moose pulled down on the cable that strung along each side of the windows inside the bus. The light attached to the ceiling containing the letters, "NEXT STOP" lit up at the same time the bell rang. Moose got out just a couple stops before the bus terminal. After getting all his stuff off the city bus, he now just had a short walk around the corner of the street and found himself at the far end of a shopping plaza.

As he walked into the entrance of the parking lot, he was quick to spot a shopping cart about 55 feet in-front of him, far from the doors of the grocery store. He decided to just start building the shopping cart right there where he found it. The heat of the sun slowing his every move as he grabbed his zip-ties and started to join the pieces together.

As Moose was assembling The GOD-BLESS Cart, an older Cadillac SUV pulled up beside him, a couple younger guy's about his age were sitting in the front seat. One of their daughter's sitting in the backseat. The passenger held his hand out over the side of the car door holding a blue folded up $5 dollar bill. Immediately going to his Artbox, he noticed the tattoos that filled the skin of their arms. He grabbed them one of his biker pictures as well as one of the school bus, for the young girl that was sitting in the backseat. They thought the pictures were awesome. They thanked Moose for the Art as he thanked them back before they drove away. Seemed like a good sign, as he had only just got to Sherwood Park and never even had the cart together before they had pulled up.

As he walked through the parking lot, he walked by a place he had met an older man during the cold months of the previous winter. As Moose had been pushing his shopping cart late one night, the older man had also been pushing a shopping cart in Moose's direction. The man identified himself as Gandolph, except he had alot less white and alot less beard than the famous wizard. He handed Moose a book about Buddhism and told him that if he read the book, he would be just like him. Moose, then asked Gandolph if he wanted to race shopping cart's? After a hearing a reply about a previous hip injury, they both continued their push off in opposite directions.

As he kept on walking, he figured he'd just push the cart up towards the Emerald Hills shopping centre. It would take him an hour to get there if not longer with the extreme heat, he had met since arriving in the new city. As he turned off the sidewalk onto the busy street heading north towards Emerald Hills, he noticed the city streets top layer had been scraped off the top and the streets there were also going to be resurfaced in the next few days. Guess it was that time of the year when all the summer road construction was happening everywhere. Moose took his time going across the deep, drops and dips within each intersection. Taking his two friends across, one at a time.

After making his turn a few block's down, he stuck to the bike path that ran along the backside of a residential neighbourhood. As soon as he got onto the bike path, he dropped onto the bright green grass under the shade of the fence. Taking a few moments to escape from the sun's brutal heat. His old oil rig coveralls he was wearing, probably weren't helping him much in the heat either.

After resting for a few minutes, he continued his push and pull until he got parked in between another Tim Horton's, beside another Co-op gas bar. This time, they were in Sherwood park. After parking the cart, he retreated in the shade along the back wall of the gas bar. The heat was really taking its toll on him and there was no way he could see himself sitting out in the sun for long.

After hanging out in the shade for only a few minutes, Moose folded up the sign up and took off again. This time heading a block down the road over to the center of the big shopping centre. As he got close, he seen a Tony Romas delivery sign on the back of what looked like a deserted building. Right close to the sign was a large quiet space in the shade. The Tony Romas was giving him a feeling

that they didn't have their doors open. After getting everything parked, he started walking up to the front doors of the restaurant. The papers taped to the inside of the tall glass door's read, "Building seized by the property owners for unpaid rent!"

The time now was just after 6 P.M. Knowing he was safe where he was with the restaurant closed, he pulled out his sleeping bag, laying it out in the parking lot and laid down. Either he was sick from something he ate, or the intense heat mixed with pushing the cart across the city, got to him. Something wasn't agreeing with him at all, as he layed there falling asleep instantly, with no energy to move.

A couple hours had passed when a kid no older than 20 was heard yelling, "Hey!" From the window of his older Isuzu SUV parked in the middle of the road. As Moose began sitting up the kid yelled again, "Do you want some change?" Moose answered back, "Bikes, Rigs or Tractors?" "Bikes!" the kid replied as Moose handed him the picture, of a motorcycle next to the outline of a chicks butt. The kid complimented, "This is awesome!" as he drove off.

Minute's later a young girl, who also couldn't be no older then 20 years old, walked over towards him. Her boyfriend or the guy that she was with, waited in the driver's seat, watching over her. She placed a McDonalds happy meal down on top of the Artbox and began to walk away. Opening his eyes and seeing her walking away he says, "I got something for you!" She stopped, turning around. He handed her a piece of his Art as she began to stare-off lost, for a minute. "This is amazing work!" She said, her eyes still had not left the paper she was now holding, before she looked back saying, "Thank you so much for the Art!" Moose

thanking her for the happy meal. As she walked away, he noticed she wore tiny little gold crosses that dangled from her ears.

As the day turned back to night and the heat retreated, Moose started to find abit more energy and was now sitting up in the parking stall. He started to woof down the happy meal that was just brought to him. Not long after and feeling a quick turn inside his guts, he was quickly running off to find an open washroom.

The dining room of the McDonalds was now closed and just their drive thru line was open. Clenching his butt cheeks, he began a fast walk pulling the cart and Artbox along the sidewalk to the end of the shopping centre where he found an A&W located inside a Petro-Canada gas station. Leaving the cart next to some city park benches, that were under a Japanese garden shade, in a park bordering the gas station's parking lot. He headed off towards the bathroom, pulling just his Artbox behind him.

The door of the bathroom, also having a paper attached to the front of it. His first thoughts were the bathroom was closed due to covid. Moose could never understand why a person could bring the coronavirus into the store and buy things, but you weren't allowed to use the bathroom. You could at least wash and sanitize your hand's inside the bathroom. Instead, the paper read, "Due to covid-19, only 1 person allowed in the bathroom at a time!" He swung the bathroom door open, letting go of his Artbox and quickly placed his butt cheeks down on the toilet seat.

As Moose was seated on the toilet in the bathroom stall, someone walked in and went over to the urinal. He began wondering how the man never seen his Artbox parked in front of the door, decided to shout out to him, "I thought it said

only 1 person in the bathroom at a time?" The man at the urinal apologizing and starting to explain he had never seen the bright white paper, hanging on the door. Moose, exited the bathroom stall, washing his hands and then headed back outside. The wheels of the Artbox banging off the frame of the bathroom door as he left.

Now back outside the gas station, he walked back over to the cart which was still parked exactly where he had left it. It was getting late, and the heat from the day had wiped him of all his energy. Even after the short evening nap he had. Pulling out his sleeping bag, he laid it out on one of the park benches under the Japanese garden shade, staring off at the stars through the spaces between the wooden rafters of the shade. Praying it wouldn't rain that night.

Waking in and out of sleep, only to the sound of someone's loud, jet exhaust pipe. Attached to a pick-up truck with some short, small man hiding inside behind the wheel. Growing a pair of nuts every time he pushed down on the gas pedal.

As the sun came out, the days heat began to show early, as it was already nearly as hot as the day before. It was only 10 A.M. in the morning now. Moose decided to change up his daily morning reading and start reading, "The 10 Keys to Changing your Financial Destiny" by Dave Ramsey. He had made about $80 dollars that morning, after a few hour's of sitting out in the early heat. As he was sitting on top of his Artbox, he noticed one of his sandal's weren't looking too healthy. The bottom grip was now only holding on by just a bit of rubber at the toes. He began wondering if walking on the hot oil range road a few days earlier, had anything to do with the fast wear. He had only owned the sandals for about a

week now. It could have also been, all the walking he had done. He pulled the whole rubber grip off, leaving the sandal with just the leather bottom remaining.

Moose decided getting new footwear was definitely going to be the first objective of the day. He started making his way back over towards the Tony Roma's he was at the night before. Knowing that he could retreat in the shade again, away from the days heat wave that had already began.

There was a Winner's store just before the Tony Roma's he could stop at and see what they had inside for footwear. Moose was still wearing his oil rig coveralls from the night before, starting to feel the wet sweat beginning to soak his white t-shirt underneath. At night, the coveralls gave him an extra layer of protection and warmth against the elements, but they were a little much on a hot summer day.

Moose always found it difficult finding shoes for his large, size 13 ski's he had for feet. Inside the store he found two options. One of the option's being, a pair of white Ralph Lauren Polo's. Polo actually happened to be one of Moose's favorite clothing brands to wear, as he had on a pair of his favorite polo boxer brief's, at the time. He also bought a pair of black Volcom shorts before leaving the store.

Then walked and stopped at the parking stall he was at the night before, where he had his nap. He left the cart there and walked over to the Taco Time, using their bathroom to quickly change in. He put on a fresh pair of white socks, his new black shorts, before lacing up and trying on his new shiny white, Polo shoes.

Now back outside with his new clothes on and standing out in the heat, he still felt drained of any energy he had in him. The heat, also throwing a weird energy in the air. Moose didn't feel right, and he really didn't want to be out in the heat

any longer. He began breaking down The GOD-BLESS cart, strapping everything to the top of his Artbox. Walking over to the bus stop and began waiting for the next transit bus.

Shortly, after the transit bus picked him up, Moose arrived at the Strathacona bus terminal. Flagging down the bus heading into Edmonton as it was starting to pull away from the terminal. Entering the double decker bus through it's very welcoming extra-wide rear doors. The bus was very spacious on the bottom floor having the extra level of seat's above. Accommodating Moose and all his belongings nicely. Soon the double decker transit bus was cruising over the Anthony Henday and was driving along the streets of Edmonton.

As the double decker bus slowly made its way towards the downtown city center, Moose, noticed all the city folk wearing face masks. Those who weren't wearing face masks, wore expressions mixed of sadness and miserableness on their faces. He couldn't see anybody smiling as he drove by looking out through the large windows of the bus. Puzzled by what he was seeing, he figured maybe they just needed some Art in their life.

He got off the transit bus downtown and stepped onto the sidewalk of Jasper ave. Finding a Costco shopping cart, no more than 20 feet from where he had just gotten off the bus. Smiling instantly, thinking that someone had left it there, just for him. Costco carts were his favorite, being built alot wider and alot more heavier duty than the other shopping carts. After Moose threw his belongings into the cart, he began walking down Jasper Ave.

Not sure what to do or where to begin, he soon found himself sitting along one of the small parks that ran along Jasper ave. Completely thoughtless about what

direction he should go and if he should assemble a cart. He had a Costco shopping cart in front of him but no thought to take the things sitting inside it making, The GOD-BLESS cart be what it could be, within minutes.

Not feeling Edmonton, he decides on a spur of the moment decision to take every dollar he has in his pocket and buy a bus ticket to Calgary. Most of the day was over, with the heat still hanging in the air. Taking his things out of the shopping cart, he hopped another city transit bus and made his way to the bus depot, buying his ticket for later on that evening. He spent the next few hours thinking about his new destination, Calgary.

It had been a long time since he had been to Calgary. Calgary was the first big city he had lived in after leaving northern Manitoba when he had turned 18. 20 years had passed being out in Alberta, living in Calgary for 10 of them. Falling in love with Calgary instantly, after experiencing his first chinook. It was -30 back home the same day it was +5 in Calgary. The warm winds that came over the mountains and through the foothills into the city were one of the most beautiful things about Calgary winters.

Not feeling ready to test the waters in Edmonton with, The GOD-BLESS cart Moose was now on the shuttle bus, as they departed to Calgary. With the heat wave over the past couple days, he was sleeping before the bus had even made it outside of the city limits.

Waking up as the bus was passing Airdrie, which was just outside Calgary, a few minutes drive when you head north out of the city. Soon seeing one of his favorite shopping malls, Cross Iron Mills to the left of him. After the mall had passed, they arrived and he was now back in Calgary. The feeling of being away

for years, coming over him. It was the early morning hours just after 3:30 A.M, when he finally arrived at their south depot location, situated inside the big truck stop.

After using the bathroom quick, he walked back outside of the truck stop, taking a moment to collect himself and take a look at the new sights. He ended up alot further south then he had planned to be. Downtown was far from him, the Deerfoot casino was just across the street and the darkness of the industrial yards and shops consumed everything else around him.

Figuring he'd head downtown at some point in the day and stopping in at the school office he had been doing his online course with. Moose headed towards 52 street, where he could board one of the first morning, city transit buses. Over to the c-train station and then take a c-train into the downtown core. He began walking down the dark streets of the Industrial park with all his things strapped on top of his Artbox, trailing behind him.

As the first city bus of the morning was pulling up and not having a dollar in his pocket, he asked the bus driver if he could get on the bus without paying fare. After the bus driver nodded his head in approval, he boarded the morning bus, continuing its circle around the city.

He got off the bus on Memorial ave. beginning to walk west, towards the c-train station, which was only a few blocks away. The tall downtown building's appearing way off in the distance in-front of him. On the way towards the c-train, he crossed the street, figuring he'd go visit an old acquaintance down in Inglewood, he hadn't seen in a long time.

After asking the next bus driver if he could catch a ride, the driver pulled away not allowing him on the bus. Leaving Moose and his Artbox standing at the bus stop. He decided to go to the convenience store just around the corner and see if he could buy an individual ticket from the counter. Using his debit card, which only had a few bucks still on it, enough to cover a single bus ticket. As he walked up to the store doors, he was greeted by a sign on the door saying, closed for renovations.

He started walking back towards the bus stop hoping that he might have better luck with the next bus driver that pulled up. When he got to the end of the strip mall, a young guy on a BMX pulled up to him. Moose handed him a piece of his Art. The kid really liking the paper he was now holding in his hands gave Moose the coins he had in his pocket which was about half the bus fare. He could make it work, once he dropped them into the coin bank at the front of the bus. After refusing to sell the kid the sunglasses he was wearing, he gave him an extra pair of sunglasses he had brought along, inside the Artbox. He had only paid a dollar for them at a dollar store, then walked back over to the bus stop.

The next bus pulled up. Moose dropped the coins he now had into the coin bank, as the driver tore off a transfer slip and handed it to him. After making a few trips bringing his things onto the bus, he got off the bus just up the road and transferred buses onto the number 1, which headed through downtown before heading into the west side of Calgary.

Getting off in the quiet community of Inglewood, just before it reached downtown. Minutes later, he was knocking on the door of his old friend, Terry's house. After showing some of his Art to Terry and having a quick chat about old

acquaintances they had known over the years. Terry, had to get going to work over at the farmers market, where he had a couple booths and Moose also had a day to get started. After leaving Terry some Art, he was quickly off, on his way again.

Instead of getting on a bus, he walked into the downtown core which was only about 20 minutes away. Seeing a coffee shop up ahead he decided to stop and use one of his gift cards he had, on a strawberry banana smoothie and an ice capp. It was only about 9 A.M. in the morning, but Moose could feel another day of dry heat already brewing with the temperature it already was.

He sat outside enjoying the refreshment of his drinks and refreshing his memories of downtown with all the familiarities he could spot. Calgary really was a beautiful city, full of beautiful buildings and beautiful people. I guess being located at the entrance into the true beauty of British Columbia, it would seem to fit. After finishing his cold drinks, he headed off deeper into the downtown core.

Always stopping to stare off at all the Art that surrounded the buildings of downtown, soon making his way up past, Olympic Plaza. Finding himself at the church corner steps along seventh avenue, across from the doors into the Bay centre. He decided to stop and sit on the short wall that ran up the steps, into the big front doors of the church. He had alot of memories from living and playing in downtown and spending alot of time down there, over the years. Meeting many people over the years. He had spent alot of time on that very corner, many years ago. 19 years had passed since those earlier days of living in downtown, Calgary.

After handing out a few pieces of his Art to a few people walking by, he pulled out his cellphone and google mapped CWC Well Servicing's location of their head

office, among the office towers of downtown. Happening to be right next door, from their head office. He found the buildings lobby with the elevators and the door was locked. A lady inside cleaning the lobby, opened it for him as he began checking the directory and finding the right floor that the office was on. He then headed into the elevator with his Artbox, the lady cleaning also joining him with curiosity in what he and the bright red toolbox were up to.

Moose walked out of the elevator and seen the CWC office to the left of him, the doors were closed. No one seemed to be around except for a few facemasks that were left strung out along the top of the secretary's desk. A paper on the door saying deliveries are by appointment only and to call this number.

After opening the lid on his Artbox, he grabbed a copy of his, "Going Home" picture that he had taken about 4 years ago up in Wabasca. While working for CWC at a camp, they had up there. He called his work "Going Home" because it had the feeling of home with the soft blues and light pinks in the picture, but also because he had taken the picture right before he and the boys, had went home for the day. The blocks of the tall oil rig hanging down over the floor, at the back of the rig.

Moose buzzed the buzzer on the side of the large glass office doors, as a man from the back in a suit appeared, holding the door open. He handed him the picture, saying he had worked for them years ago and had made some Art from one of his pictures. Figuring he'd share it with them and give them a copy, seeing how it had their oil rig in the picture. The man thanked Moose before disappearing back into the dim, dark office.

After leaving the office building and getting back outside, he walked just a couple streets over and was back along seventh avenue. His school campus was just a train ride to the north east for a few stops. When he got to the train station, he phoned his bank to see exactly how much money he had left in his account. Figuring, he'd buy a train ticket with the few bucks he might have left in his account, not wanting to risk dealing with the transit cops and receive their fine for violation of unpaid fare. The bank representative told him he had $75 dollars in his account. Not knowing where the mystery money had come from, began asking questions.

It turned out that the owner of the storage yard had refunded him $100 dollars back into his account. He had only paid $32 dollars for the storage space, thinking the owner must have felt bad afterwards after their confrontation on the phone and paid him extra for their inconvenience.

Moose then bought a ticket from the transit office located near the middle of the c-train station. After a quick stamp validating the ticket, he was on the next c-train heading to his school campus. He got off at the Franklin station, remembering old times when he had lived just a few blocks away in Albert park. Walking in the opposite direction, he only had a few blocks to walk until he reached the school.

It was quiet at the school, with just a man and a girl inside. The principal had just stepped out and apparently was on his way back, at any minute. Moose was feeling a heavy awkward energy, as he wasn't feeling very welcome. He really didn't like any of the feelings or energy that he was feeling from being there.

The principal soon walked in, making it feel even more awkward. Moose and the principal had talked before on the phone when Moose had first left school. When Moose told him who he was, he was rushed out of the school and was told to get outside while the principal held the door open. He had already been inside the school waiting for over 10 minutes for the principal's return, but now wasn't welcome inside at all. The principal saying, they had a covid-19 scare a few days earlier and couldn't have it happen again.

Moose told him about his Art that he had brought and left for them on the front desk, inside the school. The principal then telling him to go in and get it, Moose not sure why he was being allowed back into the school now. He told the principal to go in and get the Art. After such a big deal about being inside a few minutes ago, he wasn't going to go back inside at all, no matter how OK it was now. The principal told him that when he got his school bus to a permanent spot where it needed to be and settled in, to get a hold of the school and should have no problem resuming his studies. He left the Art with the principal and left.

As Moose walked away from the school, he wasn't sure how he felt about the whole experience he just had and definitely wasn't sure how he felt about the school now either. He did love the course he was enrolled in and couldn't wait to get back studying when he found a permanent home for the school bus.

He headed back to Franklin station and took the train up to Sunridge, where he could catch a bus to take him out of the city and its politics, dropping him off out in Airdrie. It was out in the suburbs and a much quieter pace than the city life. Keeping a good distance from him and all the negative city drama. He got off at Sunridge station and found a nice area of shade underneath the walkways that

stretched from the c-train station entrance, over the street and then downwards onto the city streets sidewalks.

He handed his Art to a few more people walking by that stopped, asking him random questions. While he was sitting there under the shade, a chubby girl with a cute face walked up wearing blue mechanic coveralls. Her one arm sticking out revealing her shirt underneath, pushing a Costco shopping cart with a bunch of garbage in it. Moose not sure what to make of this made up spectacle, had begun teasing, asking if she wanted to push his shopping cart for him, offering her $200 dollars a day to push it. With no real seriousness to the offer he had just made, she denied the offer, saying she just wanted to go party. Another girl came by asking him if he had any tinfoil while sporting a black eye. That was about all the entertainment Moose needed under the shade of the walkway and he decided it was time he got out to Airdrie.

Moose grabbed his things and headed up the walkway, walking past the doors of the train station, continuing down the walkway and back down to the sidewalk. When getting back on the sidewalk, he was at the bus stop exactly where he needed to be. The city bus heading out to Airdrie pulled up next to him.

7

The city bus soon exited out onto the busy Deerfoot freeway, heading up and through Cross Iron Mills. Picking and dropping people off at the big shopping mall before making its last stop in the shopping centre of Airdrie. As he walked away from the bus stop, he headed across the street over a small bridge into the small marketplace. It felt like the perfect evening in the air that surrounded him, giving him the best feeling he had felt in a long time. The warm air feeling like receiving a huge, soft, gentle bear hug. It was a very peaceful, relaxing feeling that he muchly needed.

He grabbed one of the shopping carts at the end of the parking lot and felt the time was right to build the cart and get GOD-BLESS out and shining her light. Getting his sign stretched out to the ground and start exchanging some Art and smiles with those that did pull up with their arms stretched out, holding their offerings of cash.

After having a moment to himself over in the grass along the edge of the parking lot, a young girl, no taller than 5 feet tall began walking over towards him. As she walked up, she told him she had some change for him. As Moose began to motion towards the silver pail hanging on the front of the cart, he noticed the green in the middle of her hands. The girl then acting awkward not sure if she should put the bills into the silver pail, turned around and handed him two $20 dollar bills, folded up in her hand and then placed 2 loonies that she had remaining in her hand into the silver pail. "I have something for you!" Moose told her as he grabbed her the Art print of his school bus and a few of his other print's. He explained to her what the pictures meant to him, that she now held in her hands. She gave him a couple compliments about his work before asking him for a hug. They exchanged a quick hug before she headed back over to her vehicle, she

had gotten out from across the parking lot. Carrying Moose's Art in her hands with her.

Peoples reactions to The GOD-BLESS cart were making Moose smile again as people's heads began rubber necking, turning and staring back as if they had necks, made of rubber. A lady pulled up to him just as the day was ending, handing him a $100 dollar gift card for the marketplace. He also made sure she also got some of his best Art prints.

As night fell, Moose soon came under attack by the same disrespectful arrogance of vehicles that zoom, zoomed into the parking lot, speeding next to the cart so close it could definitely be called intentional, but easily be denied if they were ever to be confronted about it. When one car came in at a high speed and maybe a foot away from the shopping cart, Moose headed over to the bank where the vehicle had parked, hoping to have some words with the driver. As he exited from the bank, Moose began asking why he felt the need, to speed through the parking lot, let alone so close to the shopping cart like that. The driver playing dumb and not taking any accountability for his actions, was exactly what Moose expected to hear from the guy. The guy pulled up to Moose minutes later, apologizing with an ice capp that he had just went and bought for him.

He soon retreated for the night and found himself hugged-up to the sidewalk alongside the TD bank. The shopping cart again acting as a wall between him and the parking lot. He had been doing well with zero bug bites, despite the high numbers of insects flying in the air, as he slept. After another long day and only the sleep he had on the bus ride down from Edmonton, Moose was fast asleep.

When he opened his eyes in the morning, a skinny guy about his age was standing at the front of the cart holding a green $20 dollar bill out over the silver pail. Moose and his early morning visitor had a cigarette together and quick chat, before the guy was offering to walk across the street to buy him a coffee. Moose denying the offer saying the $20 dollar bill was plenty. The guy then disappeared around the rear of the building, where he had a room at the hotel that was just behind from where Moose had been sleeping.

He then stood up and got to his feet, beginning to get himself ready to start his day. His phone reading a few minutes before 6, 5:55 A.M. to be exact. He then pushed The GOD-BLESS cart and his Artbox over to the spot in the parking lot he was at the entrance into the small shopping plaza, the night before.

Starting the day with reading more of his, "More Than Enough" book. A car had pulled up and started removing a fold-up tent setup, along with a fold-up table from the trunk of his car. He was setting up a booth in the parking lot for fixing windshields that contained rock chips and cracks. Soon walking up and asking Moose about his strange shopping cart set up. Moose giving his new neighbour an offering of some of his Art, before his neighbour went back to sitting in the front seat of his car, lost into the screen of his phone.

Moose, admired his neighbour's setup. Starting to daydream having a setup like his one day, having t-shirts, hoodies and hats hanging all around the large sun tent with his Art on them. A table with his Art prints or canvases being showcased on display underneath. That transformation from his shopping cart into something like that would mark the beginning stages of his Digital Art and Print Studio he dreamed of having.

Moose still hadn't received a negative remark about any of his Art and was really enjoying seeing how thrilled it got some. The smiles the Art gave, and the compliments really satisfied his feelings of pride in his work. As someone held out his piece of Art, Moose really enjoyed hearing their short story about their connection with the picture they were holding.

He decided to switch up the day and leave his new neighbour and head further down into the shopping centre. He also needed to stop by the Dollarama and pick up some more zip-ties and candles for GOD-BLESS's glass house.

As he was walking down the street, his body tensed up with a wave of emotion instantly flooding his body, a few tears slipping out and making their way behind his sunglasses. Happy he was wearing his sunglasses, and that no one could see his tears, as they flowed down his face, unintentionally.

Moose had never felt these sudden urge body cries until listening to Alan Watts chillsteps. Soon referring to Alan Watts as a spiritual mentor or guru in his life. He had found him when first starting school and really enjoying listened to the hour-long chillsteps, with inspirational music in-between his lectures.

After getting the few thing's he needed and leaving the Dollarama. Moose decided to head across the street and park the cart up in the grass at the entrance into the gas station. A few people had pulled up with change and $5 dollar bills for him, right before a young man in a white Ford F-150 parked and walked over to him. Handing Moose a brown $100 dollar bill. Moose handing the young man one of each Art print he had with him, before the young man got back into his truck. Moose didn't stick around the gas station long after that, before making his way

back over to where the windshield repair man had set up beside him. This time Moose parked his cart just across from him in the parking lot.

After getting back to where he had started the night before, he decided to call a taxi and head over to the other side of the city and find a shower. After his shower he could reset. finding a shopping cart over there and starting over.

Moose got The GOD-BLESS cart disassembled and pushed the shopping cart back with the rest of them in the parking lot. As he was getting his thing's together, the taxi pulled into the parking lot. He waved over at the taxi and it started to come his way, parking beside his things now sitting in a pile on the ground. As they made it across the city, Moose could see the truck stop up ahead, he notices it isn't much of a truck stop. Appearing to be only a cardlock pump station with a small white building in the corner of the lot. With not much of anything really going on over on that side of the city, at all. Moose decided to head north out of Airdrie. There was a truck stop and a couple gas stations on a pullout not too far away, along the busy number 2 highway.

The taxi meter inside the cab read $42 dollars when they got there. It was a little more than Moose had originally planned to pay, seeing that he would have to take a cab back into Airdrie as well. He began unloading his stuff from the inside of the cab. There were 3 buildings along the strip of the pullout along the busy highway. The first building containing a 7-11 and Tim Horton's, the second one being, a Humptys restaurant and the third one being, a 7-11 as-well with a Burger King Inside. The news Moose didn't want to hear was that none of them had showers after making the cab ride out there. He was just outside the small-town Crossfield which was only a few kilometers away.

With no shopping carts around for miles from where he was, he noticed a business sign that had been taken down with its letters stripped. Moose decided to gather his things up, heading over towards the sign near the entrance into the gas pumps. After throwing his sign over the existing old sign, he put the glass house containing GOD-BLESS on top of it and lit up her candles. Figuring its going have to do for the time being. He thought he might as well camp out there for the night and then head back into Airdrie tomorrow.

After setting up his sign, a lady selling fresh fruit on the other side of the parking lot, walked over with a bag of fresh cherries and a $10 dollar bill for him. Moose handing her some Art before she went back over to her fruit stand.

Moose now began staring off at the high speeds of the vehicles that went both directions down the highway in front of him. He never knew why, but he sure loved being surrounded by the fast-moving energy of the vehicles. Almost like the speed of the vehicles would make invisible waves of energy that rippled through the air and then absorbed into his skin. The speed reminded him of turning the throttle on the old John Deere riding lawnmower, engaging the choke from the picture of a turtle, over to the picture of a jack rabbit, just before letting go of the clutch and taking off down the laneway of his grandparent's farm.

Moose began to make a shelter under the big sign and try get comfortable, for his camp out over night, realizing that somehow, he had lost his sleeping bag between Airdrie and the cab ride out. That was going to make for a cold, miserable night he thought, but wouldn't think too much of it right now. Continuing to sit back and watch the flow of fast vehicles that never stopped racing down the highway. He could see a storm way off in the distance, constantly

throwing bolts of lightning down out of the sky but it kept on moving south across the sky, totally missing him.

Moose had a few vehicles pull up handing him a few bills. He had a girl and her boyfriend pull up, the girl inside the vehicle saying, "Do you want some change?" As she held up a small glass jar, full of change for him. he had made about $100 dollars since being out in Crossfield, covering the wasted taxi ride out there and back. Moose then crawled under the sign, relaxing and staring off lost at the traffic. Trying not to think of the chilly night he was starting to feel in the air, as the sun began setting.

An older lady pulled up handing Moose a $20 dollar bill with her strong words of encouragement to him. She told him, "You're on a good path right now! Stay on it!" Before heading off on her way.

As Moose was under the sign, he started to notice some sort of slimy slug like snail, stuck on a piece of metal sticking out of the ground. A few minutes later he seen a bunch more of the slugs, as if they were multiplying. It wasn't long after and Moose was jumping to his feet, examining anything he had sitting on the ground, as the little slimy slugs had appeared to be coming out of the ground from under the sign, filling up the ground beside him.

After getting all his stuff back onto the pavement and away from the ground. He still left the sign draped over each side of the old sign, at the entrance of the gas station. Moose hopped up ontop of the sign and began walking back and forth as if you he was on a diving board, high up in the air. He loved being perched high above the ground like that, especially above and looking out over the constant speeding vehicles in front of him, on the highway that never slept.

Now with the slug issue, his missing sleeping bag and the chill in the air really starting to set in. He decided it best to call a cab and head back into Airdrie for the night. Within 15 minutes a taxi was out at the gas station, picking him up and taking him back down the highway, into Airdrie.

Getting back into Airdrie just after midnight, as the cab pulled into the parking lot of the first big shopping centre. He paid the driver and handed him a piece of Art, with his tip. Then began unloading his belongings from out of the cab, setting them down onto the pavement next to the shopping carts.

Moose slid a loonie into the chain box attached to one of the shopping cart's, allowing it to be free from the rest. The shopping cart being the 2-basket style cart, wouldn't really work for Moose's set-up. He decided to just throw his things into the shopping cart.

Then after seeing a few tall donation bins up against the wall of the store, heads off towards the bins, hoping he can find a blanket to replace his missing sleeping bag. He sees a garbage bag sitting on top some cardboard boxes next to the bins. Moose rips the garbage bag open and the sudden smell of fresh laundry floods his nose. Inside the garbage bag he finds a small blanket, some sheets and pillowcases along with some kids towels. As he lifts the garbage bag out from the boxes, black beetles started to scatter from the insides of the cardboard box and off the bottom of the garbage bag. With all the fresh smells that were coming out of the garbage bag, Moose wasn't worried much about a few bugs getting inside.

As he walked by the entrance ways to the shops, looking for a place that he could lay down for the night, he noticed bugs and critters scattering all over along the pavement underneath the doors of the retail stores. "What is up with all the

creepy crawlies tonight?" He thought to himself. Not agreeing with sleeping anywhere along the sides of the stores, he looks out into the parking lot, deciding to pull up the shopping cart and his Artbox, to one of the rock islands. After laying down a couple of the sheets he had just found onto the pavement, he set GOD-BLESS on top of his Artbox and lit her candles.

As morning came, Moose came in and out of sleep, as people began opening the doors of the shops to begin the new day. The early morning shoppers pulling in and out of the parking lot, as they walked to and from all the stores. Moose, still feeling quite tired and enjoying his sleep under the new blanket, wasn't making much effort for getting up and starting his day.

Waking up to a man's voice calling out, "Are you alive?" Moose, sitting up to see an officer closing the door to his cruiser and begin walking over towards him. A second cruiser, now cutting across the parking lot pulling up. The second officer, got out of his car asking Moose, "Do you have any photo I.D?" Moose began retrieving his photo I.D from out of his wallet, handing it over to the officer.

Waiting for the officer to come back from his car, he noticed the candles in the glass house still flickering. The officer returned from his car telling Moose, "You have 3 warrants!" Moose starts thinking to himself, "Oh great, here we go!" The first officer, now going over to the car and looking at the computer screen inside before returning to say, "He had made a mistake, he's still learning the new job!" The officers drove away with the first officer returning handing Moose a coffee. Moose handing the officer some of his Art before he pulled away, again.

After finding a power box along one of the streetlights in the parking lot, he put all his electronics into a fabric cooler bag and then ran a short extension chord

from the bag to the power box. Charging all his things inside the bag. He then headed towards the Canadian Tire and grabbed one of their shopping carts which were more of the big basket style and pushed it back over beside the power box and next to the other shopping cart. Assembling The GOD-BLESS cart right there and pushing it up into the corner of the parking lot, 20 feet from the power box so he could keep watch of his things while they charged.

He stayed in the parking lot until mid afternoon. People had brought him breakfast, a coffee, an ice capp, a burger and a few handfuls of change along with a few dollar bills over the time spent in the corner of the parking lot. When his electronics were fully charged, he figured he'd set off down main street, through town. Finding somewhere he could escape the hot sun that was starting to shine down on the parking lot.

Moose started his trek across town, as he pushed south down Main street and was now headed towards the center of Airdrie. After noticing a sign to a smoke shop to his left he figured he'd stop and get something to puff on. Seconds after seeing the smoke shop, The GOD-BLESS cart would take a tremendous crash and was now laying on the ground, on its side. Half on Main street and half on the approach up to the sidewalk. Leaving the cart be for a minute as he began walking a quick figure eight on the sidewalk, his eyes closed taking in a moment to self meditate, before trying to lift her back up to her feet. Releasing any angry thoughts and tension from his body.

As he knelt down next to the fallen shopping cart, a man walked up asking if he could help. Moose motioned to the man, to grab at the back of the shopping cart. They both gave it a lift and brought The GOD-BLESS cart back to her feet, back

sitting proudly in the sun of the sidewalk. Moose thanked the man, handing him some Art before he carried on down the sidewalk.

Moose left the cart on the sidewalk and began heading across the street towards the smoke shop. The GOD-BLESS cart staring over at him from across the street, just as your poodle or small dog would be, sitting on the console of your vehicle when you went into a store.

Moose entered the smoke shop, pulling his Artbox in behind him. Taking a quick glance at the menu on the wall, before ordering some Rockstar Kush and heading towards the till to pay. As he heads towards the door to leave, he turns back to the till a second time to buy a pack of Canadian Lumbar rolling papers that caught his eye on the way out.

Back outside, he found a quiet place to sit in the shade outside the shop, just across the street from The GOD-BLESS cart. Having a moment to himself, while puffing, puffs of smoke up into the sky. Thinking about how beautiful the day was, how beautiful The GOD-BLESS cart looked over on the sidewalk across from him, and just how beautiful it felt to be alive.

After continuing up the road a couple blocks, he found the shopping center in the middle of town. He pulled up to the corner of the parking lot not far from the end of the drive-thru line of the Starbucks coffee shop. With the sun still coming down it wasn't long before Moose was headed into the Booster Juice for one of their refreshing smoothies, with extra whey protein. Then heading off with his Artbox to the shade under the trees, where he could watch the cart from off in the distance.

Moose wasn't wanting to be around the shopping cart much of that day either. Not sure if it was the heat from the sun or the Rockstar Kush, as he lay in the grass enjoying his smoothie. He was quite content laying there with the feel of the soft, cool, green grass underneath him. Then he has another big idea and soon is off rolling his Artbox towards the Dollarama.

Returning back to the cart, with a couple rolls of tape. He flips open the lid of his Artbox and starts pulling out some of his Art prints and starts taping them on the sides of the cart. Covering up the words, "SPARE CHANGE?" that spread across the middle of both sides of the sign. Now the sign only read, "PLEASE HELP! GOD-BLESS!" across both sides of the shopping cart with about a dozen pieces of his Art taped on in the middle of the sign. He thought it was brilliant having his Art displayed on both sides, of the shopping cart.

Moose, then deciding to finish taping the sign, under the shade of the Dental office, that was closed for the day. Also ordering a pepperoni cheese pizza with extra pepperoni extra cheese. As he was finishing taping the last few pieces of Art onto the cart, the pizza delivery man pulled up. He sat back enjoying his pizza, while enjoying the new look of his sign.

All feelings of harmony and self-satisfaction were soon taken away as a black Ford escape with K-9 security decals across it, pulled up. An older east Indian man started to unroll the driver's window. Moose, assuming he knew what the man was about to say, cut him off as he began to open his mouth saying, "If you don't have anything good to say, I don't want to hear it!" Starting to motion his hands for him to keep driving on. Moose continued to cut him off, not wanting to hear any of his negative words toward him, or The GOD-BLESS cart. The security car

drove off parking only a few feet away, rolled up his window and got on his cellphone. Moose had already planned to finish the push across town, down Main street to make it to the Wal-Mart before they closed. I guess he was heading out a little sooner than he had planned.

It was starting to get a little dark out now as the shopping cart hugged the streets edge, following the big curve around the big city park in the middle of town that led up to the shopping centre. The sidewalks not co-operating a whole lot while trying to prevent another tip over.

A car that had just passed him, pulled over on the street ahead. The passenger of the vehicle running out, his arm stretched holding a $5 dollar bill in his hand saying, "Anything for a guy getting God's name out there like that!" Moose handed him some Art quickly so they both could continue down the street without blocking any traffic that was to come. There were 2 lanes but still Moose didn't want to have any issues with someone calling the police, saying he was all over the road blocking traffic, as people phoned constantly, complaining anyway.

It wasn't much further down the road and an east Indian lady pulled up, honking her car behind him and then finally pulling into the other lane. She unrolled her window while stopping briefly, "Its dark out here!" She screamed out of her car as the 2 of them were now stopped, under a bright streetlight. Moose still wearing his sunglasses, could see her fine. He thought if that lady wasn't able to see him pulling a bright red toolbox in one hand and the shopping cart the size of a smart car next to him under the streetlights, maybe she shouldn't be driving at all. As he pushed on further up the road, Moose felt his body clench up again as the tears started to pool behind his sunglasses.

Finally arriving at the Wal-Mart, with about 15 minutes left before they closed for the night. Moose pushed the cart up to the wall beside the front doors and pulling his Artbox behind him, went into the store. Tired of sleeping out in the parking lot's like he had been, he thought he'd maybe look for a small tent. They had no tent's left, but he found a pop-up hunting blind that was only $125 dollars. Moose bought the hunting blind and replaced the sleeping bag he had lost the day before. Also throwing in a bag of Swedish berries.

As Moose left the store and walked back outside, he notices a grey unmarked police cruiser parked out-front over by The GOD-BLESS cart. Walking around the corner, he notices a young east Indian male examining The GOD-BLESS cart with his flashlight. "Is this your cart?" the officer asking Moose, before asking him for some photo I.D.

While the officer was inside his car with the photo I.D, Moose laid down on the concrete outside the store wondering if all the east Indian people that were giving him problems in the past hour, were all from the same family and purposely harassing him like this. As he took another puff of his cigarette, while layed out on the concrete, 2 more police cruisers pulled into the parking lot with their lights flashing. The officer, got back out of his car and handed Moose back his photo I.D, as the other officers stepped out of their car's, walking up to Moose. They asked him where he was planning on staying that night, Moose explaining that Wal-Mart had no tents left and had just bought a hunting blind. The officer quick to say, "A HUNTING BLIND? Is it CAMO?" Thinking the detachment was sure to receive calls of someone who had set up a hunting blind, in the middle of the city.

The officer then asked Moose if he could call in to the detachment and let them know where he had set it up, so they knew beforehand. Moose then asked the officer where he wanted him to set it up. Not getting much of an answer back, Moose pushed his thing's to the end of the parking lot near the end of the row of stores and towards the back of the building. Setting up the hunting blind next to a space that was taped off, with the words High Voltage, on one of the woodsheds behind the tape. Figuring he'd be out of the way and out of the public eye there.

Moose soon was awakened after falling asleep, an hour later to a bunch of flashlights, shining inside through the screen window's around the blind. "Hey, did you hear a car with a loud exhaust, racing around back here?" An officer, holding one of the flashlights yelled at Moose. "NO!" Moose yelled back, followed by another officer's voice saying, "Is this your Old English beer can out here?" Moose again yelling back, "I don't drink!" Moose then heard the car doors of the cruiser's close just before pulling away and leaving him alone for the rest of the night.

The next morning was the start of another super hot day. Moose pushing off a block down the road after putting his hunting blind away and getting his things together. He was only a block down from the marketplace where he had first assembled The GOD-BLESS cart, when he had first arrived in Airdrie. He decided to just park the cart alongside the edge of the parking lot, where there was a short patch of grass before turning into weeds, down into the small creek below.

Moose laid out his new sleeping bag in the grass, unloading his books and things out of the Artbox and on top of the sleeping bag. He removed his white socks and white Polo shoes from his feet and began starting to enjoy the summer day feels of the grass.

A few people had pulled up to look at the Art that was all over the sign, wondering what the shopping cart was all about?. A truck pulled up with an old greasy man who must have been in his fifty's, stepping out. He walked over to Moose, with the filthy words coming out of his mouth about sexual sin and then started to ask for directions to the mental hospital. Moose not wanting to really talk to the filthy man told him he didn't know where the hospital was and suggested using, google maps.

Not much long after, an Asian guy walked up wearing a blue Dominoes pizza uniform, handing him a small box and asking if he wanted some pizza. Moose handed him some Art while the guy stared off into the picture, asking Moose how he had created it? Answering his question, by telling him how he uses a few apps and programs he had on his cellphone and laptop. The Dominoes guy laid out in the grass, just down from Moose. Taking selfies of himself in the grass, enjoying some of the beautiful day that was shining upon them.

It wasn't much longer in the afternoon and the hot day suddenly turned into a dark sky with a storm following, not far off in the distance. A lady pulled up getting out of her vehicle, popping the rear hatch open. She handed him a box of canned foods and also handed him a brand-new, red windbreaker jacket, with a picture of a cougar's head on the front, saying that the jacket should keep him dry from the rain that was on its way.

Moose was now packing his things up off the grass before the rain hit. Heading off to find some sort of shelter for him and cart. As he pushed off through the parking lot, he seen a lady waving him over to her small grey SUV she was driving. As she was stuffing a sandwich into her mouth, she asked Moose about his

shopping cart. Moose started to explain, The GOD-BLESS cart, pointing to the picture of his school bus taped on the side of the cart and what some of the other Art pieces among the letters GOD-BLESS were to him.

Apparently, she had to leave her house that day and was now living inside her vehicle with suitcases packed in the front and back seats. She offered Moose $20 dollars for a couple pieces of his Art, also handing him a face mask for his trip up to Red Deer the following day. Then, as she played with her hair, curling it around her finger in a cute sexy-like way she said, "Well Mr. Fleming, you have yourself a good night!"

Moose continued his walk to the back of the buildings before the rain started to fall, leaving her to finish her sandwich. Finding a steel overhang that hung over the back door wrapping around a steel cage, holding a tall cell tower reaching out to the sky.

The rest of the night was spent out behind the building, underneath the steel overhang as the sky continued to release its rain that it had built up over the past few hot days. When the rain had stopped, it was late in the evening. Moose popped his hunting blind open in the grass next to alley, in the back. Taking GOD-BLESS's glass house from off the shopping cart, with him inside the hunting blind. Leaving the cart parked under the steel overhang for the night not far away, leaving all his things inside the shopping cart. Moose wasn't worried about his things he left in the cart. If someone was to bother his things, or The GOD-BLESS cart with the words GOD-BLESS stretched out across it, they would sure not like the karma that would follow them after that. If someone needed his thing's that bad, they needed them more than he did.

The first thing Moose thought about when he woke up, was the shower he never did get when he ended up out in Crossfield, a few days earlier. He decided to leave Airdrie and book his ticket up to Red deer. Moose thought he would do alright in Red deer, seeing how there were alot of oil rig companies that were based out of Red Deer. Moose also knew the bus to Red Deer dropped him off right at the truck stop and he already knew that location had showers for their truck drivers.

Moose spent only a few hours out in the grass that morning until the early afternoon. The GOD-BLESS cart only getting the attention of a few turning heads. He just enjoyed being layed out on top of the sleeping bag, enjoying another beautiful summer day. Soon to be taking apart the cart once again and calling a cab to take him back over to the other side of the city. Towards the bus depot, just down the road from where he had gone looking for a shower, days before.

He arrived at the bus depot a little early which was ok with him, it was another super hot day out and the only thing on his mind was, "Shower!" The shuttle bus soon pulled into the parking lot and began boarding its passengers. It apparently seemed there were alot of cute girls traveling on the bus that night. As they pulled up, getting out of vehicles with their suitcases and getting ready to board the shuttle bus.

After boarding the small bus, the bus driver announced that the air conditioning on the bus wasn't working. Moose decided to announce how happy he is to have brought his first face mask with him, he was excited to try on. Also, announcing to everyone on the bus, that the no air conditioning, was sure to be the perfect breeding ground for the coronavirus in the heat. Moose, noticing all

the girls starting to move in their seats to the discomfort of what they had just heard, checking and adjusting their mouth coverings, attached to the front of their face's. Moose didn't think to much about it though, he didn't believe the coronavirus was even a real thing, more of a conspiracy than anything.

An hour later, the bus had arrived in Red Deer. As the shuttle bus pulled alongside the truck stop and parked, Moose found himself zig-zagging around the crowd of cute girls that seemed to have formed around the outside of the shuttle bus. Beginning to grab his things from the back of the bus, as the driver was placing them down onto the ground. The two of them lifting the Artbox out together, from the rear of the bus.

After Moose got everything of his piled up beside the picnic table, outside the doors to the truck stop. He immediately pulled out his cellphone, opening the web browser and searching for one of Red Deer's taxi's. Shortly after calling, a silver taxi van with a plastic, "For hire" sign on the roof, pulled into the parking lot. After loading all of his belongings into the back of the cab, Moose hopped in the back seat behind the big clear plastic divider, saying, "Sylvan Lake please!"

8 Sylvan lake was about 10 minutes west of Red Deer. As the taxi pulled into the entrance of the small lake town, Moose noticed an unmarked SUV parked on the left side of the road, facing the traffic. The taxi continued to head straight though town passing the shopping centres before coming up to a roundabout, when the van suddenly slammed on its brakes. As the taxi driver swung the taxi back into the proper lane going around the round-a-bout, Moose glanced back through the rear window to see if the cab had cut

anyone off behind them. Only to see the unmarked SUV that was parked at the entrance into town, now just a few car lengths behind them and following them as they exited the round-a-bout.

They were now driving along the beautiful lake that the small lake community was built around. Moose now starting to see the picnic areas along the beach, told the cabbie to pull over. As Moose hopped out of the cab, he noticed the SUV pull over and park, just up ahead of them.

The driver remained in his seat asking Moose if he could get paid. Just before asking Moose if he even had the money to pay him. "My money is in the Artbox in the back!" Moose said to him, as the driver finally got out of the vehicle and opened the back hatch, so Moose could grab his things. Moose spent no time getting his things set down by one of the picnic tables, in the picnic area beside the lake. Paying the driver and then setting off towards the water's edge.

When Moose got to the edge of the water, he placed his belongings next to a few trees that ran along the waterfront in patches. Beginning to soak in the beautiful, peaceful, scenery of the sun, setting over the lake for the night. The beach was still quite busy, with beachgoers sitting in their lawn chairs near the water and filling the walking and bike paths that twisted along the water. Moose felt like he was in heaven and couldn't think of a better spot he could be at, then that spot, right there. Next to the waters edge, watching the small gentle waves that were slowly rolling onto the shore.

He was only at the beach for a few minute's and he was already removing his white t-shirt and his shoes. Walking out into the water, far out from shore, out towards the buoys. Jumping in for a little swim, letting the water wash the past

few days of dirt and sweat off him. It wasn't the shower he had set out for days ago, but it was much, much better and much more satisfying than any shower could have been. He splashed the lukewarm water from the lake up and over his shaved head watching it splash off his body, as it went back into the lake.

After his swim, he crawled inside his sleeping bag staring off at the beauty of the water. As the people left the beach and the trails became quiet, the waves slowed down into ripples, and when everyone was gone and the streets and parks were empty, the lake would become just as still, as the night.

As Moose layed there, not much further than 10 feet from the waters edge, he couldn't be in a better place at that moment of time. His mind was in paradise as he fell right asleep, until hearing, "Hey are you alright?" Moose opening his eyes to a tall professional, well dressed guy, not really dressed for the beach walking a few feet away from him. Moose assured him of his well-being, as the man continued walking away from him. Soon to be back inside the paradise, deep inside his mind, dreaming away.

The morning started off as a cloudy day with the wind blowing over the lake, already starting to splash waves up onto the beach. Reaching over for his cellphone which had made its way out of his sleeping bag and now lay on the ground beside him, he was surprised to find it still had life. After hitting the side button of the screen, it read 10:23 A.M. with a 5 percent battery life remaining. Families were starting to show up at the beach and about to begin enjoying the last day of the summer, long weekend. Moose decided to hop up and start cleaning up the area around him, getting ready for the day ahead.

After getting enough of the lake view in for the morning, Moose was off pulling his Artbox with everything strapped to the top of it, down the bike path along the beach, heading towards the center of town. Up the hill, past the school and heading towards one of the local grocery stores.

It was around noon and as he is walking up to the rear of the grocery market, he notices a bunch of no good shopping carts piled up against the wall. Grabbing one of the junk shopping carts he gives it a quick thrust forward, checking the durability of its wheels and how well it would travel. The wheels were fine but noticing some greasy splatters on the steel of the cart, decided to grab one of the much cleaner shopping carts, in front of the store. Then heading off towards the front, grabbed a shopping cart and pushed it off to a concrete island in the far corner of the parking lot. With a handful of zip-ties, Moose is once again assembling The GOD-BLESS cart.

While assembling the cart, A lady appeared standing not far from him wearing a green apron, an evil face and now sprouting 2 horns on the top of her head shouting, "Hey is that one of my shopping carts?" Followed by, "I want my cart back!" The short, troll-like lady walking off as Moose now seen a royal blue unmarked SUV up near the entrance of the grocery store.

Moments after the demon like lady had walked away, the blue SUV pulled up with it's red and blue lights still flashing. The shopping cart was already disassembled as the officer began to tell him about the no panhandling by-law enforced by the town. Moose, happy he had covered the, "SPARE CHANGE?" words on his sign with artwork, wasn't really worried about it. He wasn't asking

anybody for money, and he wasn't panhandling in his mind. Moose was on an Art fundraiser for his school bus.

The officer didn't care to ask Moose for his photo I.D. but after a short argument with Moose about pushing the shopping cart back to the front of the store. Moose said, "No! I'm not doing it!" The officer grabbed the empty shopping cart and pushed it back towards the front of the store, while Moose got his things strapped back ontop of the Artbox and started walking away.

The only other options he had for getting a shopping cart, were the Canadian Tire and the Wal-Mart that lay just across the road into town, on the other side of the shopping centre. He headed off towards the Canadian Tire parking lot and left his things sitting in front of the Dollarama. Then took off across the dirt field towards the Wal-Mart. Grabbing a shopping cart that was sitting along the edge of the parking lot and began to walk at a fast pace back over to where he had left his things.

Just as Moose had started to push the shopping cart, an older lady in an older SUV driving by unrolled her window, screaming at Moose, "I'm not security, but I'd take that shopping cart back!" Moose shaking his head in frustration said to himself, "What is up with this place and their shopping carts?"

Neighbouring the vacant dirt lot that separated him from the Wal-Mart was the Nabors head office and yard. Moose had worked for them years ago, while up in Slave lake. The yard beside the office, completely full of oil rigs and iron. Looking like every oil rig, the oil giant owned, was stuffed in behind the steel fence, surrounding the property.

As Moose was assembling the cart a second time, a young girl pulled up eating a muffin, supporting a Dollarama work shirt and handed him 2 twoonies and a loonie. Moose, handing her back a piece of his Art in return, sees her instantly smile at the bright pinks of the picture. "I love it!" she said, as she headed in for her shift at work.

After The GOD-BLESS cart was assembled, Moose headed off towards the drive-thru just a few blocks up the road. Moose, enjoying the breeze that the wind was throwing in the air, soon was parked out on the street at the end of the drive-thru, completely off the property. The manager came outside wanting him to leave. He wasn't even on the property of the coffee shop but she still did not want him there as she went back inside.

Not much longer and the police were pulling up again with their light's flashing in front of Moose. He had already parked the cart across the street, after the lady had came out and left. The officer was fine with what Moose was doing and liked his sign, as long as he wasn't going up to vehicles and asking for money. Driving off also without asking Moose for his photo I.D.

A yellow jeep TJ pulled up, asking what the shopping cart and sign were all about? He pointed to the picture of the school bus, attached on the side of the cart. During his explanation, he handed her and her grandson in the backseat, one of his Art prints. The lady handing him a folded $20 dollar bill in return before saying, "My son works on the oil rigs!" After thanking him for the Art, she began to pull away as the young boy's smile opened, "You're a great artist mister!" he said, as they drove off.

Another girl pulled up in a 4-door Mazda wearing a black face covering on her face. She unrolled the passenger window handing Moose a folded up $10 dollar bill. Moose handing her a piece of his Art as she then started to pull off the face mask she was wearing, revealing her growing smile as her eyes were lost in the Art for a moment. "That's beautiful! I work in the oil and gas! I'm going to hang this up in my office!" her lips replied, just before she too pulled away and continued on her way. Moose smiling with satisfaction as he returned to sitting ontop of his Artbox.

The sky now turning more violent by each minute had Moose realizing he was out of cigarettes, began to fold up the sign, locking the latches on his Artbox and heading off towards the gas station, just a couple blocks away. As he is parking The GOD-BLESS cart, just before walking into the store, a man at the pumps filling up his truck, shot him over a dirty look. Shaking his head in disagreement with the shopping cart that read GOD-BLESS across it. An overweight lady with the face of a 60 year old chain-smoker, bellowed towards Moose while getting into her car. He went into the store, bought his cigarettes and then pushed the cart over, across the street.

As Moose began to lower the sides of the sign down, a lady pulling out of the alley behind him, pulled over asking about the shopping cart, "Do you want a coffee or something to eat? I'm going to Timmy's!" she asked him. Moose staring up at the wicked sky turning dark quickly, replied back, "I'd love a coffee!" "I'll be right back!" she said.

Moments after she had drove off for the coffee, the wind had gone from zero to 100, as a sudden air tsunami lifted The GOD-BLESS cart in the air and slammed

her down on her side, just grazing Moose's arm. The trees across the street pretty much touching their toes, as any loose piece of garbage, or anything not tied down was being flung and hurled up into the air, flying down the streets. The rain drops now starting to fall, following the sudden wind attack. Moose quickly grabbed the side of the shopping cart and with a sudden powerlift brought The GOD-BLESS cart back up to her feet. Grabbing his Artbox and the cart, started to quickly walk off towards the gas station across the street. Seeking refuge along the back wall of the store, breaking most of the wind.

As Moose is hugged up against the wall, a young lady carrying boxes from inside the store out to the dumpsters walked by. "I hope its ok if I sit out the rain for abit back here!" Moose yelled at her over the storm. "Yea I think your fine!" She yelled back at him as she quickly walked away from the dumpster retreating back inside the store. Her upper body curled up, bracing for the raindrops that were shooting down from the sky, striking her.

A few minutes later, the lady with the coffee pulled up to the back of the gas station handing Moose his coffee, while trying not to get hit by any raindrops splashing around her vehicle. Moose handed her a piece of his Art quickly, only allowing one raindrop to hit it before she has it in her hands, inside the dry vehicle. They chat briefly, yelling at each other over the noise of the storm which had began to let out shouts of thunder. The bolt of lightning was her cue to roll up her window and get back to where she was going.

Moose had his cellphone charging in the outlet at the back of the gas station and after a few more bolts of lightning, Moose thought it be best to maybe find proper shelter for the night. Turning his cellphone on, it had a 3 percent battery

life, he quickly opened google maps, finding a Days Inn just across the street, on the other side of the gas station. $95 dollars for the night. Instead of suffering the long night of the cold, wet, nasty weather, Moose quickly walks over towards the hotel.

Leaving The GOD-BLESS cart in the parking lot and grabbing his Artbox, he wheels it into the lobby of the hotel. After paying for the room, Moose noticed the tattoos on the front desk attendant's arms. "Do you like bikes?" Moose asked him. The man behind the desk replying, "Yea, I just can't afford one right now, my truck payments are taking everything from me!" Pointing out to his truck out in the parking lot. Moose handing him the Art print of the motorcycle and the chick's butt. "That's sooo cool! That's definitely going up in my living room!" The man behind the desk said, just before Moose started to roll his Artbox down the hall beginning to find his room. Then headed back outside to disassemble everything from the shopping cart, bringing everything inside. Pushing the bare shopping cart over, tucking it away along the edge of the parking lot to the hotel.

Moose, now inside the hotel room with everything, grabbed the TV remote, turning on the TV just before hopping up onto the bed to rest for a quick minute. Flipping through the channels on the TV, before stopping at Tosh.O. That show was always good for a good laugh. Moose always loved stupid, silly humour.

Setting the remote down on the nightstand, he got back off the bed, removing his slightly soaked clothes and turned on the taps to the tub. Squirting some shampoo from the little bottles that sat next to the sink into the tub, he began to splash his hands in the water trying to build bubbles. Moose then grabbed the glass house with GOD-BLESS inside, setting her up on the counter next to the sink.

He lit 5 candles beside her, before shutting off the lights and lowering himself into the bathtub. Only his eyes sticking out among all the bubbles, much like a crocodile with it's eyes sticking out of a river into the darkness.

With Moose's eyes closed, his mind had started to slow down from its quick gallop, producing memories of the people he had met over the past couple weeks, thinking of what his own kids were doing. Remembering all the smiles and compliments he had received from his Art and just all the harmony and beautiful things he had experienced throughout the days.

His body than tightening up and beginning to release tears as they flowed down the front of his face and were adding themselves to the semi-hot bath water. His body trembling, as his arms tightened their wrap around his knees as he now sat up in the tub. The 5 flames of the candles, dancing to their reflections in the mirror.

Shortly after getting out of the bath he was in a deep, deep, sleep. Loving every minute, on top of the pillowtop, queen size bed. He didn't move an inch while he slept, or get the chance to do any dreaming that night.

With the sun shining in through the window and the singing of the morning birds, the storm had passed and left a beautiful, bright beginning of a new day. Moose woke up around 8:30 A.M. and quickly hopped into a pair of his coveralls. Throwing the few pieces of stray laundry into the garbage bag of dirty clothes, he called a cab. As he got outside, the shopping cart was still sitting where he had left it, before the freak storm had ripped through the town. An older fellow pulled up and Moose threw the garbage bag of dirty clothes into the trunk, right before driving off along the beach. Heading to the laundromat, downtown.

As they pulled into the parking lot of the laundromat there was a construction crew doing utility repairs under the street, out front of the laundromat. Moose entered the laundromat and was greeted with a friendly smile from the Asian lady, who was busy folding someone's laundry they had left behind with her. Filling two of the washing machines and beginning the wash cycle, Moose headed back out into the parking lot.

2 large backhoes were pulling and biting at the earth beneath them as if they were 2 giant steel dinosaurs taking bites out of the ground. A small bobcat was making trips back and forth, dropping off bucket full's of special rock for the construction crew. Moose began taking pictures of the equipment as he got a few shots of all 3 buckets in sync, with the supervisor wearing his red vest, standing with one leg up like a great explorer, directly in the middle of the 3 buckets. Moose then went down to the water's edge while waiting for his laundry, capturing some beautiful shots of a 12-foot aluminum boat, drifting about 15 feet from shore. 2 red paddles resting in the holsters of the small boat, with a red life jacket sitting on top the seat.

In between taking pictures, Moose went back into the laundromat to switch the clothes into the dryer. Returning and starting to fold his clothes, as the dryers continued to dry, spinning the rest of his clothing that were still damp. After finishing folding all of his laundry, he was back inside the same old fellows cab and heading back towards the hotel. The time was just hitting 11 A.M. He had already called the front desk ahead of time and had asked for a late check out for noon.

After checking out of the hotel and getting his deposit back, Moose grabbed the shopping cart he had tucked away along the edge of the parking lot. Pushing it across the street and began assembling it. While Moose was assembling The GOD-BLESS cart he looked up, "The churches of Sylvan lake Welcomes You!" Was sprawled across the wooden sign at the entrance to the lake. "Well, I think we're at the right spot!" Moose, said to GOD-BLESS.

The artwork taped onto the sides of the sign, had seen much better days. The storm had destroyed the Art. Moose started to pull off all the Artwork and began replacing it, while under the huge welcoming sign of Sylvan lake. After finishing the cart, with all the new artwork taped up again on both sides, he wondered which way he should go.

The lake being just a couple blocks one way with all of its beauty, or the drive thru line a couple blocks the other way. Moose wasn't in too big of a hurry to get going back to Red Deer yet. Another night at the lake would be quite alright with him. He pushed off towards the drive thru with the thought's of knowing at some point later that day he'd be returning past the big welcoming sign, towards the sights of the lake.

After pulling up to the drive thru, it wasn't long after and an older Chinese couple pulled up and stopped. The lady passenger, unrolling her window and stretching out her arm with a $10 dollar bill in her hand. Then a guy about Moose's age in a blue semi truck stopped, waving him over from the cab of his big rig. An older lady in a purple Nissan SUV with a confused face following with another older lady in a silver van, both with the questions of curiosity about

Moose and his shopping cart. All to be captured with the Art in their hands that Moose gave back to them.

He decided to make the push across town over to where he had the confrontation with the demon troll lady the day before. Where he had first attempted to put together The GOD-BLESS cart, in the small lake town.

Moose got just up the street, before seeing the big sign for Valhalla and decided to stop in for a quick second. Quickly running into the store and back out with some B.C Gabriola. As Moose continued to walk up the street, he found a magnetic decal for the door of a vehicle that read, "Sylvan Lake Weed Inspector" Across it with a picture of their coat of arms in the corner. Moose picked it up off the side of the street, where it sat in the dirt. "Is this for real?" He thought to himself as he couldn't not stop to laugh for a minute before pushing the rest of the way.

As Moose pulled into the parking lot, he decided to park across from the entrance into McDonalds. Which was also at the far corner of a grocery store. As he pulls up, a truck drives by with a, "Luvin 50" license plate.

A little while later, A pretty gal pulled up in Ford limited truck and walked into the gas bar. She wore a soft like silk, spring dress, and a halo of flowers sitting on top of her head quite similar to that of GOD-BLESS's. After giving him a folded up, blue bill she asked Moose, "How much Art do you still have in your toolbox?" Saying she was, "Headed off to drink wine with a bunch of her girlfriends and she might bring her friends back to buy all of his Artwork!" Moose chuckled to himself before saying, "There's quite abit of Art left in the Artbox!"

It wouldn't be long and Moose was pulling The GOD-BLESS cart back over across town, back to the drive thru near the lake entrance. Where he could get out of the sun of the concrete parking lot and under the shade of the grass. Also getting to try some of the B.C Gabriola he had picked up on the first pass across town.

Moose, now back across the street from the drive thru, was hanging out under the trees. Meanwhile, the B.C Gabriola has him feeling like he's riding the B.C. Gondola, up to the top of the trees.

A man and lady dressed in leather support patches for one of the various motorcycle clubs, their bottom rocker patch displaying the community they were involved with were sitting next to a couple bikes on the grass near the edge of the parking lot. Fulfilling their thirst's and having a break from their ride out on the open highway. Moose decided to walk over a piece of his biker Art and an oilfield one for them.

Sitting on their bikes, they stop at the cart on their way out of the parking lot, Handing Moose a folded bill in return for the Art that he had given them. Moose, blessing their bike ride ahead as they pulled away.

The evening became quiet, until a bird flying close by, pooped, almost landing on him. Moose watching it fall from the sky and splat not much farther then 5 feet away from him. Decided it was time to get going towards the lake and not let anymore of the day, get any messier then the close call he just had. Moose then headed off towards the scenery along the beautiful lakefront, with his red Artbox in one hand and GOD-BLESS in the other.

Passing under the entrance to the lake that hosted the big wooden sign, "The Churches of Sylvan Lake Welcome You!" Across it. The same spot where he had assembled The GOD-BLESS cart earlier that same day and had re-attached new Art onto the sign.

Steering his 2 friends off to the side of the large pedestrian path leading up to the beachfront, as they were now in the way of an older couple jogging in their athletic gear from down by the lake. As Moose continued swerving around the pedestrians that inhabited the path down by the lake to the beachfront, he handed out his Art and shouted out to them, "The sign at the entrance said, The Churches of Sylvan Lake Welcome You! I Think we're at the right place!" An older couple walking by that happened to hear Moose shouted out, "You're in a good place!"

Finally, back down at the beachfront, he was close to the spot where he had camped out the first night he got there. Pulling GOD-BLESS down to the water's edge, parking the cart, so her glass house hung out over the water's edge. He then kicked his shoe's and socks off and began to soak in the beauty of the scenery and the warm beautiful air it created around him.

Grabbing pieces of his Art and handing them out to people as they walked by him and GOD-BLESS parked at the beachfront. Moose becoming addicted to the compliment's he was receiving from them, for his work.

A rough, older gentleman carrying a garbage bag appeared and started digging through the garbage bin's that were closest to Moose. Moose, grabbing a picture of the semi-tanker and the pumpjack from his Artbox ran it over to the old man. After a quick chat and a mention of a book that Moose had been thinking about

writing. The old bottle picker stared off, speechless at the Art for a few moment's before saying to Moose, "Well if your book is anything like your Art, It will be a best seller!" Then continued on with his search for any bottles or cans in and around the garbage bins that were spread out along the pedestrian path.

Moose shouted out to a couple that happened to be walking by, "What do you think? is that a good spot for her?" Pointing over at The GOD-BLESS cart hanging out over the water. "Yup, looks good!" the couple shouted back with the guy sticking up his thumb. Moose looking back at the cart thinking to himself, "Damn, does she ever look good!"

The flames of her candle dancing out over top of the water. The sky, a beautiful mix of bright rays of purple and pink that glowed for many hours as the sun fell behind the trees and rested ontop of the hills, on the far side of the lake. Moose, feeling like he was already home inside, had no problem falling asleep again, as the late-night kids who frolicked up and down the dark paths of the night, giggled and shouted out while he slept.

9

Moose, woke up to another bright beautiful, hot, hot day down by the lake. Deciding to leave Sylvan lake at some point later on that day. He had been gone for a week and a half now and still had some distance to go, to get back. Families and people were starting to come take in the lake's beauty and have picnics that morning, so Moose thought he'd give them their time since he had enjoyed his spot at the lake all night to himself.

Moose was close to the entrance of the picnic area. He decided to give out as much Art as he could as he walked the short distance over to the entrance. Moose, ended up talking to an older fellow, who really enjoyed the Art alot. Pulling a $10 dollar bill from his wallet and handed it over to Moose, with a small bible.

Moose continued to hand out his Art, among the rows of people that started to grow in front of the parking ticket machines. The older fellow he had been talking with, had went and placed Moose's Art in his vehicle, so it wouldn't get ruined, while he was down at the beach. Stopping by Moose on his way back, this time handing him a $50 dollar bill. They started getting to talking again as Moose was beginning to disassemble the shopping cart. When the taxi he had just called, pulled up behind the shopping cart. The man then offered to drive Moose into town, saving Moose the $50 dollar bill he had just given him. The older fellow insisting on driving him, taking off to tell his wife who was sitting down at the lake. Moose explained to the taxi that he was going to cancel, giving him a $5 dollar bill for showing up.

After cutting all the zip-ties holding The GOD-BLESS cart together and placing everything in a pile across the road from the pay machines. Moose happened to

see a white SUV, with a Sylvan lake by-law decal across the side of the door, creeping through the parking lot in front of the ticket machines, glancing over towards Moose across the street.

 The old fellow then pulled up, loading everything into the back of his truck, Moose pushed the bare shopping cart back across the street and left it in the empty parking stall that sat next to the pay machines. Which had a metal sign at the front reading, "For emergency vehicles only!"

 The old fellow and Moose had a great talk on their way into the city about life, oil rigs and the Bible. As they entered the city, Moose asked if he could drop him off next to Gaetz ave. which was just ahead of them.

 As they got close to Gaetz ave. Moose pointed over at the shade across the street from a foods store that was to the left of them. The old fellow hanging a left and backing up to the spot in the shade that Moose had just pointed out to him. Moose and the old fellow placed their hands together and tilted their heads down, "Amen!" And Moose is out the door and placing his stuff from the back of the truck, in a pile on the ground. Not wanting to waste anymore time from the great, kind fellow he had just met.

 A big thank-you followed with a handshake and the old fellow was back off to his wife, while Moose is running over to grab a shopping cart and run it back across the road. He decided to just throw his stuff into the shopping cart and build it later, saving a confrontation like when he had first built the cart in Sylvan lake.

Now arriving on Gaetz ave. which was only a block away, begam looking both ways determining which way he should go. Seeing a McDonalds in the distance to his left, he decides to head left.

As the traffic on Gaetz ave. slowed down for a minute and showed Moose a break in its flow, he crossed over the one lane and hopped the shopping cart up in the meridian of grass, splitting up the 2 lanes. When Moose attempted to cross over the second lane, as the front wheels touched down the shopping cart flipped onto its side and as Moose let go of his Artbox, it too flipped onto its side.

The light then turned green, as the oncoming traffic began to come his way. Moose scrambling to lift his things up and off the pavement and get everything to the other side of the street. Only to hold up traffic for a quick minute, with his slight embarrassment. When the traffic cleared up again, Moose ran back over to where the spill occurred to make sure he didn't lose anything from the accident. Only a few black zip-ties lay scattered along the roadway.

After getting everything back up and over the curb across the 2 lanes of traffic, Moose decided to just start building the shopping cart right there. As he's setting up The GOD-BLESS cart, a girl walked by, heading into the bank. As she came out of the bank, she stood across the street facing him with her cellphone out, pretending to act normal while standing there. Moose yelled over at her, "Don't forget to get your selfie with GOD-BLESS!" She was quick to reply, "No thanks!" Moose, finishing up attaching the last zip-tie holding The GOD-BLESS cart together, began walking up to the McDonalds he had first seen when making his way onto Gaetz.

After making it to the intersection of the McDonalds, he now spotted a Tim Horton's to the left of him. He didn't even have to cross the street and could have avoided the spill all together if he had just kept walking up the side he was on. This time he crossed back over at the intersection, knowing it'd be much safer to cross. Regardless of all the stares from the windows of the vehicles stopped, waiting for the green light.

After positioning The GOD-BLESS cart in the grass that separated the street from the drive-thru line, an Asian girl walked up to him curious about what he was doing with the large double-sided sign that had his Art on display. She threw some change in the silver pail telling Moose, "Go get something to drink from inside!" Before walking away with a piece of his Art. A couple guys with a couple folded $5 dollar bills followed. The compliments Moose continued to receive about his artwork lifted him up ontop of the world, once again.

A lady walked up to the sign asking Moose if he remembered her from Sylvan lake? Then handed him a $10 dollar bill, wanting another picture for her son that worked on the oil rigs. As they get chatting away again, a bald man wearing a pair of oakley sunglasses walked up, handing Moose a bunch of bills folded together. Moose not bothering to count the bills, lifted the lid of his Artbox dropping them into the corner. As he began to pick out some of his Art to hand to the man, the man said to him, "There's $75 dollars there!" Moose then handed him one of all of his best Art prints, from within the Artbox.

The sun was sure hot again that afternoon, Moose headed inside, ordering an ice capp with the change that the young Asian girl had left him in the silver pail. After returning outside with his cold drink, he rolled his Artbox over to the shade

in the alley that hosted a short concrete wall. Leaving The GOD-BLESS cart right where she was parked.

As Moose was making his way to the entrance of the alley, a young kid appeared panhandling near the rear corner of the coffee shop, alongside the drive-thru. No more than 25 feet from The GOD-BLESS cart. He couldn't be any older than 20 years old. A scrubby look to him fixed with red sores and scabs on his face, looking like your typical victim of hard chemical drugs. Moose stopped immediately at the sight of his competition he hadn't known was there. Walking over a piece of his Art to the kid. "That's all I got for you!" He said as he walked away from the young kid, hoping the Art might inspire him with some kind of positive feelings inside or maybe add some inspiration to him if he was a young artist at one point, before letting it collect dust.

While Moose was sitting on the short wall along the entrance to the alley, the kid with the panhandling sign he had just given the Art to, was already walking away from his spot at the rear of the coffee shop. Maybe he already got enough money for what he needed, or the Art had got him thinking, either way his competition was now leaving the area.

Moose had begun to ponder the idea of where he was going to sleep that night or set up his hunting blind. Not bothering to use, while camped out in-front of the lake. Moose kind of wanting to make his way back closer to his school bus, decided to take the shuttle bus that was leaving later in the evening and not spend any nights in Red Deer.

The shuttle bus wasn't leaving until 8:30 P.M that evening, that gave him plenty of time to make his way there and he'd have no issues with catching the

bus. Moose decided to push-off away from the busy Gaetz ave. back towards the truck stop near the entrance of the city.

While walking through the residential neighbourhood he was greeted by a kid on a BMX. As the kid biked close by the shopping cart, with the looks of bewilderment, Moose said to the kid, "Hey I got something for you!" As the bike started to make a turn back towards him. Moose asked the kid again, "Bikes or Rigs?" The kid still having a puzzled look on his face.

Before he could answer, Moose already had made up his mind for the kid, pulling out his sure to win picture, of the motorcycle and the chick's butt. The kid's face lighting up like your Christmas tree would on Christmas morning. "I can have this?" the kid said. Moose replying, "It's all yours!" just before grabbing his Artbox and The GOD-BLESS cart with his other hand continuing down the road.

The kid did a quick circle with his BMX, one hand on his handlebars, the other hand holding the Art up to his face. Looking like he was having a tough time pedaling, as he kept stopping every few feet to stare into the Art again. The Art taking control of him, or maybe it was just the chicks painted butt.

Moose got a little bit further up the road before he decided to stop out-front near a 7-11 which of course, would have a small Tim Horton's express coffee shop and drive-thru inside it. As he began unfolding the side flaps of the sign of the shopping cart, A young native lady, with what looked like here her mom or older friend in the passenger seat next to her, stopped. The lady in the passenger seat saying, "It's not much!" as she held out 2 twoonies in her hand to give to Moose, Moose telling her, "That's plenty!" As he handed them a couple pieces of his Art watching their face's show the expressions of, "Oh, WoW!" across them.

With not much going on in the heat of the afternoon and the time still ticking away closer to his bus departure. Moose figured he'd pack up and get closer towards the truck stop.

He was singing away while listening to his headphones, a Martin Garrix mix was playing, "In the darkness, in the middle of the night!.............." Moose was singing away, out loud, walking down the pedestrian path to the truck stop. Looking up to notice a guy who had stopped in his tracks, staring at him. Moose thought the man must have thought he was crazy or losing his mind.

Only less than a block from where the shuttle bus was to depart for Edmonton that night, Moose rolled past the gas pumps and decided to prepay his ticket for that evening. As he walked into the store, the cold air from the air conditioning hit him with a sudden wave of refreshing coolness. "Maybe I should just hang out in here and wait for the bus!" Moose said out loud to himself, but also loud enough that the lady behind the till could hear, "Sorry, I'm afraid your not allowed to do that due to covid-19 safety policies!" She was quick to reply after hearing the comment.

The office for the shuttle bus was situated inside the store of the truck stop. Its door closed with a paper on the front saying, they had stepped away and to call this number if needed. Moose pulled out his cellphone, calling the number. Wanting to make sure he had his seat reserved on the bus for later that night and could just pay the driver.

Knowing it would be an issue leaving The GOD-BLESS cart pulled up in the parking stall in front of the doors to the truck stop, unless he disassembled it. Already surprised the lady behind the till hadn't said anything yet. Moose figured

he'd push it across the street to the middle of the parking lot between another Tim Hortons and a neighbourhood steak house.

A younger lady in a truck first to pull up, "I don't have much, but I have a Tim's gift card I just put $20 dollars on it if you want it?" Moose replied, "I don't want it, if you just got it for yourself!" "I got it for you!" she shouted back. "Ok then!" Moose told her as he went on to tell her he usually buys boxes of tea with the gift cards for out at his bus. He handed her a picture of his school bus and a picture of the oil rig amongst the bright pink backdrop as he began telling her, "I've become quite fond of the chai tea lately!" She told tell him how wonderful his Art was, before pulling out of the parking lot.

As Moose is pacing up and down ontop the edge of the curb in the parking lot, he began thinking about his bus ride in an hour. He also couldn't stop thinking about the steak from the steakhouse aromas, that were flooding his nostrils. The shuttle bus was still going to be another hour until it arrived. He decided to treat himself to some long-awaited, cravings of a steak off the grill, as he walked off towards the doors of the steakhouse.

As Moose walked into the doors of the steakhouse, he is greeted by the hostess. A beautiful girl wearing the brightest of blue eyes, sweetest smile with the voice of an angel. He began asking her about the steaks as she began to spread out a menu on her little hostess station, suggesting to Moose, a steak sandwich. Moose wanting a thicker cut of meat, went with a 10-ounce New York striploin, with a side of mushrooms and ceaser salad. As she began to fold up and put the menu away, she mentioned to Moose that he could wait in the lounge if he liked. Moose, looking at The GOD-BLESS cart through the window beside the

front doors while still lost in the sweet angel-like voice of hers, let's her know he'll be back in 15 minutes.

Moose figured now that he had ordered the steak, he should start to disassemble The GOD-BLESS cart and get ready for the shuttle bus that would soon be there. 15 minutes later, everything is strapped on top of his Artbox, as he's running the bare shopping cart over to ditch it next to the dumpsters. Making his way back to the steak house, licking his lips while thinking about his steak or someone else's he could smell on the char broiler as the aromas drifted out into the parking lot. Moose, also kinda wanting to go see the cute angel of a hostess that he placed his order with, again.

With less than 30 minutes left before the shuttle bus was to arrive, Moose sat down on the picnic tables out front of the truck stop, finally biting his teeth down into the medium-rare steak. Moose's head is in an instant whirlwind of yum. While he's eating, he's listening to a girl talking though the drivers window of an SUV not to far away from him. Wondering if maybe she was waiting for the shuttle bus as well.

Now, a tow-truck was pulling up in front of the picnic table where he was sitting. It turned out the girl had locked her keys in her car, and the tow truck was here to save her day. Moose, pulled out a picture of an antique tow-truck he had taken at the beginning of spring up by the Edmonton airport and handed it to the driver of the tow-truck. The girl now beginning to go on to talk about how horrible her day was leading up to locking her keys in her vehicle. "Well I hope this makes your day a little better for you!" Moose says while handing her a piece of his Art. She smiles as Moose can hear the stress and anxiety leaving her voice while she

continued to talk, just before hopping into her unlocked car pulling away with a smile towards Moose, as she left the parking lot.

After the girl with the locked vehicle had left, the shuttle bus pulled up beside the truck stop. The bus driver hopping out and Moose paying for his ticket before starting to move his things from beside the picnic table over towards the rear of the shuttle bus. The driver of the bus opened the big cargo doors on the back of the bus. The cargo area is completely stuffed and full, so was Moose after eating his steak. It was a good thing half of the stuff in the cargo area was coming off the bus and staying at the Red Deer location. The bus driver began to remove the big tupperware containers that consumed half of it, then wheeled out a large plastic diesel tank on a dolly to the rear of the bus. It must have been as tall as Moose at 6 feet. Moose helped the driver play the game of Tetris in the cargo area while they got everything loaded.

After they had placed the sign in the back all you could see was GOD-BLESS across the cargo area, before closing the doors. Moose saying, "Well I think we'll have a safe travel to Edmonton!" The driver of the bus smiling back at him, "Thanks for the help! I couldn't have done it without you! Don't worry about the extra charges for the extra baggage!" Moose thanking him as they both got onto the bus and were soon pulling onto the number 2 highway and a little less then a couple hours away from their arrival in Edmonton.

10

As Edmonton got closer, he was now only one bus away from home and only a couple hours away from his school bus. The anticipation of getting back really starting to grow inside of him. Moose got off at the southside drop off location and began walking away from the shuttle bus after collecting his belongings from the rear of the bus. It was getting late into the evening and thought he'd have a much more relaxed night on the south side of the city opposed to the 118 ave. drop off location. 118 ave. being on the northside which was notorious for its drug dealer's and prostitutes that hung out along the avenue.

 Pulling into the parking lot along Gateway, directly south from the city's downtown core. Next to a few wooden barriers, protecting vehicles from the unevenness of the parking lot, Moose noticed a shiny chrome shopping cart laying next to the barriers flipped over on its side. Quickly flipping the shopping cart back onto its feet, he noticed it was much smaller than your average shopping cart. The chrome had a different shine than most, much like an old BMX, so he'd make it do. Moose began assembling the cart just as an Edmonton police SUV pulled into the parking lot. Slowing down for a moment, as it creeped by before continuing out the far side of the parking lot.

 Not long after, Moose was spinning off along Gateway ave. heading north with the skyline of the Edmontons downtown way off in the distance, pulling into the entrance of a 7-11, just off the corner of Whitemud and Calgary trail. As he parks his things off to the side of the entrance, he could see and hear a group of street kids with their bags and bikes pulled up to the back side of the store. Moose

figured he'd stay near the entrance, giving him a good distance from him and the street kids of the city.

Within minutes of being there, a tall, young native thug approached The GOD-BLESS cart wearing black gloves that were cut-off at the finger's, with a black facemask. Moose decided to hand him a picture of the eagle head, that looked like he meant business, Moose called Mr. Eagle. As Moose handed the young native man the picture, the aggressiveness in the mans body began to fade. Removing the black face covering he was wearing and saying, "You did this? This is good! My family name is Antinanco, which means eagle of the sun in our culture. I love it! I can have this?" Moose says, "It's all yours!" as the native man asks, "If Moose would say a prayer for him?" Moose had never been asked that question from anyone and a little caught off guard, from the aggressiveness of the street thug that had just walked up to him. Moose answered back, "Well I'm not much of a preacher, I've never really prayed for someone before." The young native man shaking his head in agreeance said, "I respect that, can I say a prayer for us?"

Moment's later, Moose and the native man had both their hands held together in-front of them, their heads tilted down with a prayer of blessing's and things to be thanked for from the Lord before both men saying, "Amen!" and then carried on with their night.

The native man with his face still lost in the Art, tried handing Moose the coins that were in his pocket. Moose, not willing to take all the money this man might have on him, quickly refused taking the coins. The native man walked off towards the street kids, staring off into the picture of Mr. Eagle.

A couple people pulled out of the parking lot with their arrogant looks and laughs of disgust towards Moose as his bowels now started to move. A girl walking up to the store, shouted out at one of the cars, "What you haven't seen somebody suffer before?"

Moose, then heading off in the direction of the 7-11 to find a bathroom, walking into the store to find a piece of paper attached to the door saying, "Closed due to covid-19" Frustrated once again, he heads towards the McDonalds and finds the doors locked with a paper attached to their front window, "Dining room closed, drive thru and curbside pick up orders only!"

Looking like no where else was open in sight, he headed back to the 7-11 next door, asking the attendant at the till for a garbage bag and some napkins. The person behind the till, handing him some napkins but not giving him a garbage bag. Moose says, "You can't give me a garbage bag? I'm going to take a crap outside! Unless I can use the bathroom?"

The workers behind the till, now looking at Moose in shock, like he was crazy or never had to go to the bathroom outside before. Moose was used to crapping in garbage bags while working out on the rigs, it wasn't nothing new to him.

He began folding up the flaps of the sign, on each side of the cart. After strapping them up, he headed north, up Calgary Trail. After making it just a few blocks up the road, he could feel his bowels turning again. Noticing some tree's over to the right of him with the proper kind of privacy and the napkin's he was given, heads over towards the trees beside the building. As Moose makes his way under the tree's, he suddenly stops. Just a few feet in front of him are a couple tent's, someone had set up camp in the corner of the building. Not wanting any

confrontation with anyone who may be inside the tents he quietly heads back over to where he left the cart and his Artbox. Quickly grabbing them and with a quick squeeze of his butt cheeks continues the push north, hoping to find a bathroom or another set of trees soon.

A few blocks up Calgary trail, Moose see's a cheap motel he's stayed at before in the past. They like to refer themselves as a, "Laidback motel!" Moose figured he'd spare himself another night out on the street and make use of the motel bathroom. He begins to pull his Artbox and The GOD-BLESS cart, up to the lobby.

As he walks up to the front door, there is a paper also attached to it reading, "Call this number if needing the front desk attendant." As Moose begins to pull out his cellphone, an Asian man and a young girl with the character of a prostitute come down the stairs out of one of the hotel rooms on the upper level. The Asian man opening the door to the motel lobby as the 3 of them walk in. The young girl giving the man now behind the front desk, some money from her pocket beginning to explain that she would have the balance she still owed before morning. Leaving out the part that she'd probably have a few dates to see that night before she could clear up what was still owing on her room. She then walked back out of the motel lobby, aiming a smile at Moose on her way-out. Thinking Moose might be a potential client to help her out with the money she needed to come up with. Little did she know, Moose pulled up to the motel with a shopping cart! Not just any regular shopping cart, The GOD-BLESS cart!

"Do you have any room's available?" Moose asked the Asian man. Just the two of them were now standing in the lobby. "It'll be $95 dollars with tax! $100 dollar

deposit!" the man behind the desk replied, "Room 205!" Moose paid for the room and then was handed the key.

Moose found the room about half-way down the first wing of the motel and parked his things near one of the stairwells leading up to the upper level. Suddenly, Moose was all eye's and ears of the whole motel, as he began to carry his belongings up to his room.

An old guy came onto the balcony, looking down at Moose for a second. Moose, wondering if his shiny chrome shopping cart would be safe in the parking lot of the motel until morning, asked the old guy if he'd help him bring the empty cart upstairs. A native couple had begun screaming at each other in the background. The old man shooting him a look like he was crazy, before walking back into his room. Moose, picked up the shopping cart and carried the cart up the stairwell by himself, setting it in his motel room. Then headed for the long-awaited bathroom, not even taking the time to turn on the TV.

Moose checked out of the motel at 11 A.M the next morning. Carrying the shopping cart back down the stairs and began to assemble The GOD-BLESS cart, right in the parking lot of the sketch motel. As he began to pull his Artbox and the GOD-BLESS cart out onto the sidewalk of Calgary trail, he began to look down each side of the street before deciding to keep heading north like he had been, before stopping at the motel.

On the way, Moose stopped at the Booster juice a couple blocks up. Loving their refreshing fruit smoothies, he entered the store and ordered a large, ripped berry. The sidewalk outside, then stretched across one of the lanes of the street and was for cyclists and pedestrian commuters of the city. Moose loving the extra

wide lanes while he pulled his 2 best friends along, kept walking until resting on the corner of Whyte ave.

It was a beautiful, sunny day as he sipped on his ripped berries through the straw inserted into the top of the bright yellow and purple foam drink cup. It was one day, that would soon be always remembered. Moose decided to leave the signage on the sides of The GOD-BLESS cart folded up. All day, only the words GOD-BLESS would stretch across the shopping cart, with GOD-BLESS inside her glass house, hanging in front.

"I got something for you!" Moose said to a lady walking across the intersection of Whyte ave. Handing her the pink picture of his old service rig pulling five and a-half inch tubing in Unity, Saskatchewan. The driller with his hand's up to the sky appearing as if he were praying, but actually was just pulling on the winch line that had wrapped itself up in the elevators. I'm sure the driller was praying every second while out on the rig, let alone that very second, staring up towards the sky with his hands held up. "Well, that's amazing!" the lady said to Moose before continuing her walk across the busy intersection.

A man on a bike soon pulled up, asking if Moose could sell him a cigarette before asking him about the shopping cart. Moose gave him a piece of his Art and a cigarette telling the guy on the bike he didn't want his money. Moose then continuing to hand his Art to anyone walking by that would accept his offering.

Moose finishing his fruit smoothie and admiring how beautiful The GOD-BLESS cart was shining away under the sun, soon headed east down Whyte ave. To meet the people of the day that were all living their own life's journey and happened to be out and about soaking up the day.

Moose made it a couple blocks down the avenue before seeing a wooden sign reading, "Art Emporium, supporting local artists!" Intrigued about the wooden sign that had just appeared, he began parking, The GOD-BLESS cart and wheeled his Artbox into the entrance of the Art Emporium.

The small entrance of the old building spanned out into a huge room with 3 large white pillars that ran down the middle. The walls inside were full of all sorts of magnificent and amazing pieces of Art, as well as having little display booth's housing local artist's Art on display, for the world to see. He noticed one booth up in the front, whose artist must have had a love for cat's. All her paintings were of creepy, magical cat's that she might have locked up in her castle far, far away….. full of cats.

Moose walked up to the counter, behind a lady that was buying a few pieces of Art that she must have fell in love with. After she was done, Moose asked the young girl working what the Art Emporium was all about? She responded with, "This is a place where we display local artist's work for them!" Moose quickly saying back to her, "Where were you guys months ago?" "We've only been open a couple months!" She said, "Well I guess I've only been missing out for a couple months then!" Moose chuckled to himself as she smiled.

Moose then asked if he could give her some of his Art. She began to tell Moose that she wouldn't put it up on the walls unless he was going to pay for a spot. He had not even begun to think about putting it up on the wall, but was only offering to give her some of his work. She then said, "Sure if you want to give me some of your Art, I'll have it!" Moose then started placing some of his Art pieces up on the

counter next to the till, "This is really good! You have some great pieces here! And its different from any of the Art, from any of the other artists!"

One of the guys Moose had just gave some Art to a few minutes earlier, popped in the doorway of the Emporium and held up the Art, now behind a glass frame he must have just bought for it. Then left, leaving Moose another huge smile of satisfaction, as he stood inside the Art Emporium.

Moose then asked about any available spaces she had for rent, he was shown a spot up in the corner of a wall, that was $30 dollars and the only space she had left. Not very fond of the corner she had showed him and not having given it much thought of showcasing any of his Art or had any of his best Art with him he decided to leave the Art Emporium. Leaving with a sudden wave of new thought's and ideas, blossoming inside his mind about his Art and one of his new favorite places. After he left, he found a plastic shopping bag with 3 frames inside, sitting on top of The GOD-BLESS cart, waiting for him outside.

Grabbing The GOD-BLESS cart, he walked to the end of the block, crossed the street and stopped among a couple park benches. Parking GOD-BLESS out towards the street for all passing by, to see her light. Moose sat back on the park bench, as visions of Art still filled the back sides of his eyeball's.

There was a dirty, homeless looking man sitting on the grass, behind the benches. The scruffy man's black boot's sitting out beside him, while he pulled at his hair, appearing to pull his hair out, or what he had left for hair anyway. The man stood up and sat down on the bench next to Moose and began to light up a cigarette butt. Moose offered him one of his cigarettes from the open pack, he had just pulled out of his pocket.

The man, beginning now to start talking craziness, talking about the government inflicting people with cancer so their deaths would look natural and then went on to tell Moose about how someone had shaved the top of his head. Moose only now noticing the buzz left behind by the shaver, after the man had mentioned it.

Moose looked over at the man, "You look like BOZO the clown to me!" As he appeared to be balding where the hair shaver had left the short clearing on the top of his head. With long dirty twists of what might be blonde hair that dangled around the sides of his head. The scruffy man smiling, but not saying anything about Moose's remark.

The Art Emporium was still spinning gears inside Moose's head as he thought, "You know what? What's $30 dollars?" Moose decided to head back over to the Emporium and get the only space available for the sake of it. As Moose walked in, the lady at the till says, "Back already?" Moose replying, "Yea I'm thinking about grabbing that Art space!" with a big smile on his face. "Ok, great!" she'd say, I just have to check with my boss to make sure the space hasn't already been rented out!" Pulling out her cellphone and after a quick chit chat with her boss, she tells Moose, "The space is available but there is also a space on the middle and last pillars!" That ran across the middle of the huge room. Moose looking at the giant white pillar in the middle that he couldn't even wrap his arms around was quick to say, "I'll take it!" "The space is $75 dollars a month." She tells him. There was nothing to think about or any thought needing to make the decision. Moose's Art was going up on the center pillar of the whole Art Emporium and nothing could top that or the feeling he was suddenly beginning to feel. He handed the girl the

deposit he had just received back from the motel earlier, using it for the new rental space.

As the waves of warm, fuzzy feelings started to flow throughout his entire body. Moose left a copy of all the Art he had with him at the time, walking out of the Art Emporium with one of the biggest feelings of accomplishment he had ever felt in his life. His Art was going up on the center pillar of the whole Art Emporium and he felt more amazing than ever inside. As he walked back out the front doors, he said say to her, "I must go get some of my real Art! I wasn't expecting anything like this to happen today!" While hosting a smile on his face that stretched, from one ear to the other.

Moose, now back on busy Whyte ave. during the mid-afternoon, immediately heads off in the opposite direction of the crazy, BOZO the clown man, after leaving the Emporium. His mind was now made up for the day. He was going to relax the day away with GOD-BLESS. The flaps of the cart were staying folded up. Leaving the only the white letter's, GOD-BLESS displayed for all those to see and he'd hand out as much of his Art as he could to those that crossed him and the cart's path that day. Doing so while displaying a smile so huge on his face that no one or anything could destroy or take it from him.

Moose decided to leave Whyte ave. heading for the parks that stretch and wrap along the banks of the river, separating Whyte ave. from the downtown core. The parks having incredible views of the river valley below, among the skyline of Edmonton's downtown buildings.

He began heading down the twisting, winding sidewalk of the riverbank, entering the pedestrian path that ran alongside the Strathacona bridge. The

Strathcona bridge was a beautiful, large bridge of steel that was the first bridge of its kind, back in the day that offered 3 modes of transportation across it. Motor vehicles in the middle, with pedestrian walkways on each side. Railroad tracks for trains, were on the upper level. Moose stopped in the middle of the pedestrian pathway to take some pictures of GOD-BLESS peering over the river valley below.

 When he exited off the walkway of the bridge, he parked The GOD-BLESS cart up on a hill overlooking the river valley below. Being such a hot day out and just finishing his push and pull across the bridge, with his two friends, he parked his Artbox under a big, beautiful tree.

The park along-side the river valley was full of people laying and suntanning in the grass, people on rollerblades, bikes, and electric scooters whizzing by all enjoying the beautiful summer day that it was. A few stopping to take a quick picture of The GOD-BLESS cart as it was parked up on the hillside with the sun shining down on her.

As Moose was resting, sitting under the shade of the large tree, 3 darker skinned fellows walked over asking him if he knew Jesus Christ and if Moose had given his life over to him? He said to the 3 gentlemen, "I have left my life in the hands of the man upstairs and if I was to die today or tomorrow, I've accepted that!" Looking up and pointing to the man, up in the sky.

Minutes after chatting with the 3 men, Moose found himself kneeling on the ground in-front of one of the men. The man kneeling down in front of Moose as well, their hands raised up before them. The man in front of Moose started speaking words, with Moose repeating them back to him. The 2 older gentlemen stood with their arms crossed, chanting words Moose couldn't understand. As

Moose continued to repeat the words of the man who was knelt down in front of him, the man rose up, placing a hand on Moose's back and the other hand on his chest and began shouting to the sky. Asking to break any curse's, evil thought's and evil ways of Satan, breaking their chains and casting them out of Moose's body, while the man adjusted his hand on his chest down to Moose's stomach, shouting to remove all diseases and sickness out of Moose's body, alternating his hand back and forth from Moose's stomach, to Moose's chest. Moose wasn't sure what was really going on. He hadn't seen the sky spin into a storm with zeus's lightning bolt splitting the tree in-front of them yet, but something definitely was going on. Moose hoping any evil spell or curse trapped inside from that life or a previous one had been lifted out of him and sent off without ever coming back his way.

After the chanting and ritual, they just had in the middle of the park, under the tree. Moose and the 3 men embraced themselves with a small prayer, shaking hands just before watching the 3 men that had just entered his life, walk away and disappear into the city streets, connecting downtown. Some of his artwork also in their hands.

Moose then rolled his two friends up in the grass where he could lay out on his sleeping bag and take a minute to soak in all that had just happened and reflect a little upon it. Laying there, soaking up as much of the sunrays of the beautiful day as he could before getting up and heading off towards Jasper ave. in search of some refreshing beverages. As Moose began the uphill climb from the riverbank up into the busy metropolis of the downtown core, The GOD-BLESS cart ran over his right heel, stopping Moose in his tracks. After a quick shake of his right foot in

efforts to shake the pain away, he continued to pull his best friends into the core of the city. Moose forgiving GOD-BLESS for her nasty heel bite she just gave him.

Soon finding himself at the Tim Horton's on Jasper ave. Parking The GOD-BLESS cart next to another shopping cart that an old man sitting outside, owned. Moose offered to get the old fellow something to drink. The old man refusing the offer as he shook the coffee that was in his hands. Moose walked back outside holding a drink tray with a strawberry banana smoothie as well as an ice capp to replenish, after the hours in the heat and the push up the hill.

Moose began to ask the old fellow if he wanted to race shopping carts? Also warning the old man that his cart was built for speed. The old man refusing the request to race. "Thanks for the Art!" he said, while Moose pushed off with his 2 friends, deeper into the city along Jasper ave.

Moose visioned one day, playing his favorite video game, "Super Mario Kart" and being able to pick The GOD-BLESS cart as an option from the bonus carts, when you had finished and unlocked the game. Moose played a lot of Super Mario Kart over the years, even still as an adult.

Soon parking The GOD-BLESS cart, alongside the sidewalk and heading into the Shoppers, returning with a case of bottled water. In preparation for the night ahead and the heat that was still coming down around the edges of the downtown skyscrapers. As Moose kept on his travel along Jasper ave. he also kept handing out as much of his Art as he could.

 He seen a really rough looking girl that appeared to be sleeping, in the corner of a doorway next to the Starbucks. Moose pulled out a bottle of water, with a piece of his Art, leaving both in front of her for when she did wake up.

Moose kept on pulling his 2 friends until he had entered the huge courtyard of the Sir Winston Churchill square, which was located right across the street from the Art Gallery of Alberta. He parked the cart not to far from the tall, large statue of Sir Winston Churchill. The statue wasn't too attractive, Churchill had the appearance that he was just involved in an oil well blow-out, on an oil rig and looked like he was covered in foamy black oil. Another man later would say to Moose that he looked like he was covered in mud. Maybe Churchill was a man that liked to play dirty, Moose didn't really know a whole lot about the famous man. Moose did know that if a statue was ever to be built of him, in that scale of size, he better look alot better then Churchill did.

As Moose hung out by the statue and was handing out pieces of his Art, he had began to also offer bottles of water to those who were walking by and looking like they might need to wet their lips that were dry from the suns heat. A short, older man, quickly downing one of the water bottle's Moose had offered him grew wide open eyes when he finished, looking at Moose and said, "You're a savior!" After slamming back the water.

Moose then seen not too far away a native girl pushing a shopping cart meeting up with another native girl also pushing a shopping cart. As they got closer, Moose yelled out to them, "YOU GIRLS WANT TO RACE?" Then began to warn them how The GOD-BLESS cart was built for speed. The 2 girls started shaking their heads no, as they tried not to laugh at the request he had just made. Moose couldn't find anyone wanting to challenge his GOD-BLESS racer. Moose stayed at the statue handing out more bottles of water and pieces of his Art before finding his way back towards Jasper ave.

After handing his Art to a couple guy's walking down the sidewalk towards Jasper, the men were quick to say, "Thanks, a true artist, is an artist that will give his Art away!" Moose taking the encouraging remarks, smiled as they all continued their walk down the sidewalk.

When Moose got back to the corner of Jasper ave. he noticed all the newsstands were empty, since covid-19 a lot of the free newspapers and magazines that used to fill the newsstands on every corner had been discontinued. Moose took the opportunity to place his Art on every corner and began placing his Art in the front spaces of all the newsstands, up and down, on both sides of Jasper ave. downtown. Shouting out, "Fresh news! Read all about it!" as he filled the empty newsstands up with his Art, now out on display.

Moose was starting to enjoy the compliment's for payment for the Art alot more than any of the money he had received or was offered for his Art. After all the newsstands had been filled, Moose headed off with his 2 best friends back to the park alongside the Strathacona bridge again, to take in the sunset for the night.

As Moose began to enter the park, he was greeted by a couple playing with their two kids who must have been about 4 or 5 years old. He handed their parent's some Art before asking if he could give their kids some Art as well. The parent's said that it would be ok as they called their two young boys over and told them to go see Moose. Moose handed the kids each a picture. One of the women on horseback donning, Canada flags at the Calgary Stampede and the other one of his school bus. Moose really enjoyed seeing the looks of the 2 young kid's light up

as they began to stare off and get lost into the pieces of paper they were now holding in their hand's.

Moose then layed down his sleeping bag in the grass along the pedestrian path. Across the pathway, The GOD-BLESS cart sat perched up overlooking the bridge and river valley once again, the candles in her glass house flickering away as the night slowly rested on the daylights end. Moose yelling out at random pedestrians walking by, "Don't forget to take a selfie with GOD-BLESS!" as he giggled away to himself.

Soon another guy pushing a shopping cart full of junk and random tools, appeared pushing his cart over next to Moose in the grass, before laying down. Moose offered him too a bottle of water. As the man that had just pushed the shopping cart there downed the entire water bottle, he looked over at Moose saying, "You're a real blessing!" Moose smiling back at the man before asking the new strange man, "Do you want to race cart's?"

Moose was soon setting off with his 2 best friends again back off towards Whyte ave. and back over the Strathacona bridge he had crossed over much earlier that day. His feet sore from all the walking and the ankle bite he had taken earlier from the cart. His white polo shoes that were less than 2 weeks old already starting to show holes through the bottoms. He crossed over the bridge making his way back to Whyte ave. As he passed the Art Emporium again, he stopped at the bench's where he had met, BOZO the crazy man at the start of the day.

He wasn't sitting at the bench long, before someone came up and started chatting with him about The GOD-BLESS cart and his Art. The guy impressed with Moose's Art, offered him some change from his pocket. Moose denied the offer,

Moose said today was a day for giving and he wasn't accepting money from anyone for his Art that he was handing out.

 Moose had lost the silver pail somewhere at the beginning of the day, so there was nowhere for people to place the coins anyway. It seemed to fit the day. The man insisting that he leave his coin's, left them on the park bench beside Moose. Moose left the coins sitting on the park bench when he decided to push off with his 2 best friends again, a few minutes later.

As he kept making his way down Whyte ave. Moose stood on his Artbox taping his pictures up on the hangers attached to the side of the streetlight posts that were empty and were supposed to be displaying banner's. Flooding his Art everywhere he could on Whyte ave. as well.

Now, ending up across the street from the 7-11. Near the entrance of the gas station there was an Edmonton police officer who had a man pulled over in his car. Moose stopping, handed the officer a piece of his Art, who had now started to walk away from the window of the car he had been talking with. As Moose was talking to the officer another young male and extremely tall lady cop walked up not wanting any of his Art that he was offering.

Moose remembered the abnormally tall lady from the springtime, she had kicked Moose off the grass of the church one afternoon when he was relaxing in the grass for a moment. The officer had biked up on her bicycle saying she was part of the Whyte ave. beat patrol. This time she asked Moose in her witch-like voice, "Where are you sleeping these days?" Moose thought he better get moving before she happened to want to ask him for some photo I.D and begin to play some of her silly games.

The young, male cop, asked if Moose had a phone number? As Moose began walking away. Moose quick to reply, "It's on the back of the Art!" As the officer flipped over the paper in his hands to see Moose's name, phone number and email on the back of the of paper he was holding. Moose continued his push away from the 7-11, pretending like he never heard anymore questions if they were to ask him anymore.

Moose only got a couple blocks away before a guy that reminded him alot of an old friend Brent stopped and began chatting with him at a bus stop. Moose telling him about The GOD-BLESS cart, then handed him some Art. The man too also offering to give Moose $20 dollars in his hand, that he now held out. Moose telling him about his day of giving and not being able to accept it. Moose told him, "Yesterday I would have taken your money, but today is my day of giving!"

The satisfaction of giving Art and receiving the compliments was all Moose needed and he didn't need anything else. Moose was full of food and water, had money in his pocket, his Art was in most of all the newsstands up and down Jasper ave. and his Art was going up on the center pillar of the Art Emporium on Monday. Moose was on top of the world, inside and out. There was no one that could shut off the light he had shining deep inside him.

Moose soon found himself heading back down into the river valley. This time instead of over the bridge. He was along the side of the freeway that went down into the valley and up the steep hill on the other side. Happy it was dark now and there wasn't much for traffic out on the streets. A few vehicles stopping in front of Moose as he came into view of their headlight's before changing lanes around him.

One of the vehicles being an Edmonton police cruiser as it flew by. Moose thinking, they were going to pull back around and pull him over, but they kept driving forward. Moose not sure if he could make it, his feet extremely sore now. Especially his ankle where the cart had run over his heel earlier. Turning around wasn't an option and he couldn't stop there.

Just as he got to the last couple hundred feet of the freeway before the sidewalk appeared again, he'd have another Edmonton cruiser fly by him in the lane next to him, pretending as if they didn't know he was there. Moose was then off the freeway and back onto the sidewalk, right after that, just the steep hill going up into the downtown core, lie ahead.

Moose's feet were in pain with every step, the weight of the cart unbearable, as it kept nipping at his heels, climbing up the steep hill. Soon to hear the wheels of another shopping cart, coming his way as another native girl was pushing a shopping cart going down the hill. Looking like she wasn't really enjoying herself a whole lot, trying to keep control of the shopping cart as she went down the steep hill. A native guy soon appeared behind her. Catching up with his own shopping cart. Moose immediately asking them if they wanted to race down the hill. Both of them scared of racing Moose's cart built for speed as well, shaking their heads no. Moose happy they were too scared to race because he probably wouldn't have made it back up the steep hill after racing them down it.

Moose wasn't sure if he could make it up the hill as it was, he soon seen a sidewalk shoot off to the side from the sidewalk he was on. Off to a set of emergency doors at the base of one of the residential towers that sprawled across the hillside overlooking the river. Moose decided to pull up to the back of

the door's and maybe camp out there for the night, which was about halfway up the hill. He layed down his sleeping bag and parked The GOD-BLESS cart beside him, blocking the wind that swept across the hillside.

The wind was howling through the buildings along the hill, and the smell of rotten piss, that consumed the stained concrete, was becoming unbearable. After about 10 minute's Moose had to get up and carry on, he couldn't take the smell anymore. The pain already shooting through his feet with the first steps he had made as he began the last stretch up the hill.

The candlelight in the glass house, flickering away, as it lit the way up the hill. Moose, walking with a slight limp now finally making it to the top of the steep hill and could see Jasper ave. Just a block away he continued the push knowing he could take a minute to catch his breath when he got to Jasper.

All the pain in his feet and arms from the big hike, all seemed to disappear instantly, when he first noticed the newsstands on Jasper ave. They still held all his Art displayed in the front of them.

 Moose handed a black man in a suit on the corner of Jasper, some of his Art and than pointed at the newsstands explaining what he had done earlier that night. The black fellow loved it. He loved The GOD-BLESS cart, as well and thought it was awesome. He and Moose had a great chat together, with smiles on both their faces, loving the moment. Even though it was now a cold, windy night at almost 3 A.M in the morning. The man before heading on his way also held out a green bill for Moose, Moose denying the offer explaining to him that it was his day of giving. Even if it was past midnight and technically the start of a new day.

Moose hadn't realized it was that late in the night or that early in the morning now. Not sure of anywhere he would feel comfortable laying down for the night, being back in the downtown core. He headed towards the 7-11 figuring he could use a big bite hotdog after the trek back to Jasper ave., again. Not even sure why he had bothered to even come back to the downtown core.

As he continued down Jasper ave. his smile of pride kept growing every time he passed his artwork displayed in every newsstand he walked by, also helping block out the pain he felt in his feet after each step.

As Moose walked into the 7-11, he noticed no food spinning on the rollers that cook the hot dogs and taquitos. "No hotdogs!" Moose shouted out. A younger black guy wearing a 7-11 uniform stopped filling the shelves with the new stock laying in the middle of the aisles and asked Moose, "What do you want? You're my guest here! Ill make you whatever you want!" Then headed behind the counter and started to make Moose the hotdogs he was craving. Moose handed the two guys working some of his Art as they began asking how Moose had made the Art.

Sitting outside of the store, while finishing eating his hotdogs and after the long day of events, decided it be best to disassemble The GOD-BLESS cart for the last time and call a taxi. His feet in so much pain, he couldn't imagine pushing or pulling the cart, anymore. After about 30 minutes a van with the taxi light ontop, pulled into the 7-11 parking lot, to pick him up.

Just as Moose finished loading up his belongings into the back of the taxi and is about to hop in the back, a young native kid walked up to the cab asking him for any spare change. Moose handed the kid a $5 dollar bill but was unable to hand

him any Art, which was now tucked away in the back of the taxi. The kids face lit up thanking Moose, saying, "You're a life saver!" As Moose pulled out of the parking lot in the taxi. The young native kid grabbed the empty shopping cart Moose had left against the wall and pushed it off into the darkness, of the parking lot.

Moose, got the taxi to head towards the hotel, that was just a block down from where the bus was to depart later on in the day, figuring he'd camp out somewhere around there, until closer to the time, the bus was to leave. Moose, asking the driver to pull up alongside a patch of grass just behind a log fence near the rear of the hotel.

Paying the driver, he began to unload his things out of the back of the taxi. Moose laid his sleeping bag down, half under a spruce tree and used the fold-up sign of The GOD-BLESS cart, as a support for his head. Crawling into his sleeping bag and immediately falling to sleep after the long, wonderful day he had.

Moose finally woke up in the late hours of the morning to a light, misty rain. The spruce tree keeping him mostly dry with just his sleeping bag showing a little dampness, on the outside of it. As Moose is lying there waking up in the mist of the rain, he notices a ladybug, crawling in and out of the rim of his sleeping bag, in front of him. Moose gazed off at the pretty ladybug, watching its little legs run at full tilt, under its big shiny, shell of spots. Moose was always mesmerized of the cute ladybugs his whole life. Always feeling drawn to them for some reason. He remembered times he'd burn brush that had been sitting in a pile out in the yard and as he grabbed handfuls of the branches and leaves, he'd uncover hundreds of the little lady bugs that had made the brush pile their home.

The bus wasn't leaving for a few hours, but Moose figured he better get up and start heading towards the depot. Beginning the walk across the parking lot, at the rear of the hotel. His shoes and feet were soaking wet and he could hear his worn-out, white polos, squishing with every step. His feet also in pain with every step he made towards the depot.

When Moose got to the bus depot, he asked the guys if he could leave some of his thing's inside the lobby. They were quick to say that they weren't responsible for anything if it went missing. Moose left his things in the corner of the lobby, beside the pop machines. He laid the sign from the cart over the top of his things with the words GOD-BLESS reading out. Moose figured if someone went and stole his things under the words, GOD-BLESS they could just have them.

Moose rolled his Artbox outside and to the end of the small strip mall, that used to cater to the old airport, when it was located inside the city. The old runway was right across the street from where he was currently standing.

The last shop of the small strip mall was a promotional shop, offering prints on shirts, jackets, and mugs and etc... for businesses. Moose walked in inquiring about the costs of getting some of his Art put on t-shirts or a hoodie. Moose began setting some of his work onto the counter, the man also really liking his Art, asked Moose if he wanted to throw one of his works, onto a t-shirt. The man behind the counter taking the picture of the motorcycle with the girl standing next to it.

Moose had his first t-shirt pressed and was going home with it. Kinda like his going home present, just before leaving the city on the bus. Moose didn't know

what to think, but sure loved how Edmonton starting to show him some positive, after all the negative he'd endured there.

 As Moose walked back outside, he seen a woman leaving out one of the doors to the right of him, getting into a white truck, parked out front. A bumper sticker on the tailgate of the truck, read, "I ♥ oil and gas!" Moose quickly grabbed the picture of the oil rig, amongst the pink sky, running it over to her before she pulled away. The woman also really loving it, saying, it was definitely going up in her office!

11

Moose called John, who had been watching his school bus, out on his property while he was gone. Moose, telling John that he was on his way back in a couple hours and asked if he could stay the night out at the bus, until they moved the bus in the morning. John not really liking the idea and not wanting to get in any trouble with the county. Ended the call saying, to call him in the morning and they could figure out, getting it towed tomorrow, sometime.

The bus left Edmonton right on time and Moose was sure happy to be almost back. It had been a long, couple weeks. Just as the bus was about a half hour from home, Moose received a call from John. "Yea, Moose it'll be fine if you go stay in your school bus tonight and I'll just come wake you up in the morning and we'll go from there!" John said over the phone. Moose suddenly smiling with a huge weight, lifting off his shoulders, not worrying about where he was going to stay that night and thrilled to be soon at his bus, "Thanks John!" Moose shouted back into the cellphone.

Moose got his things unloaded from the shuttle bus and right away loaded into a taxi, 10 minutes after arriving in town, he was back out on range road 14, pulling up to his school bus he had been gone from, for 2 weeks now. So happy to be back inside, he sat down in his office chair, threw his head back and closed his eyes.

The phone rang a few times the next morning, knowing it was John and was still too early for Moose wanting to answer. He left it ringing for the first few times. On the forth or fifth call, Moose answered and within minutes, John was backing up his tow truck and began lifting the back end of the school bus up, raising it in the air.

On the way towards town, John asked Moose if he wanted to stop by the Tim Horton's on their way out of town. The Tim Hortons he was offering to stop at was Moose's spot, where The God-Bless cart was born. Where he had sat for days, during the weeks prior to his big trip. Moose said, "No just the bank is fine!" So he could pull out the remaining of his CERB payment, to pay John for the tow.

They were heading just an hour and half south of town to park the school bus at a seasonal lake lot at the campground, where Moose could park the bus for the whole year.

He never did end up getting the money for the wood stove after his trip. He did get alot of good memories and alot more than just heat, the only thing the woodstove could have offered him. Moose still had lots of time left before winter.

Moose, now had a story to go write!

The End

One of the many service rig's Moose had worked on.

Moose checking pressures of an oil well.

A picture Moose took while working a night shift in 2012.

Moose's rig pulling 5 and a half inch tubing in Unity SK.

Moose along the river valley in Edmonton AB.

The birthplace of The God-Bless cart.

GOD-BLESS inside her glass house.

169

Parked on the railroad tracks when heading to the storage yard.

Outside the Wal-Mart in Airdrie AB

After covering up the spare change? Words.

Enjoying the summer day in the grass in Airdrie AB.

The sign out in Crossfield AB.

Staying out of the rain in Airdrie AB.

First night at the beach In Sylvan lake AB.

Heading to Walmart in Airdrie AB.

GOD-BLESS at Sylvan lake AB.

The picture's Moose took while doing laundry.

171

The welcome sign leading to the beach at Sylvan Lake AB.

More pictures at Sylvan lake AB.

Along Gaetz ave. in Red Deer AB.

Outside the truck stop in Red Deer AB.

After assembling The GOD-BLESS cart in Edmonton AB.

The Art Emporium on Whyte ave.

Crossing the bridge over the river valley.

Under the tree where Moose met the 3 men next to the river valley.

A random church in Edmonton AB.

The old man's shopping cart outside the Tim Horton's on Jasper ave.

A random piece of Art.

The Sir Winston Churchill Statue.

The 2 native girls pushing shopping carts in Edmonton AB.

Moose's Art along Jasper ave. he placed in the newsstands.

The GOD-BLESS cart with the old Strathacona bridge in the background.

Moose's Art hanging on Whyte ave.

Parked at the drive-thru on Whyte ave.

Crossing the old Strathacona bridge.

On the freeway heading back into the downtown core.

The sign that Moose found in Sylvan lake AB.

The inside of Moose's school bus before leaving on his big trip.

The first t-shirt moose had pressed before heading on the shuttle bus home.

The corner Where Moose left his things inside the bus depot.

Manufactured by Amazon.ca
Acheson, AB